860 OLD-TIME SILHOUETTES

Edited by
Carol Belanger Grafton

DOVER PUBLICATIONS, INC.
Mineola, New York

PUBLISHER'S NOTE

The silhouette is a form of representation that has been used by many cultures throughout history—from Paleolithic times, the ancient Greeks and the Chinese of the Tang Dynasty down to such modern illustrators as Arthur Rackham. Silhouettes are prized by current artists and designers for their crispness and wit, and for the innumerable uses to which they can be put. Following on the success of her first anthology, *Silhouettes* (Dover 23781-8), Carol Belanger Grafton here presents a wide-ranging and diversified selection (incorporating new subjects such as circus, military, professions, music and transportation) assembled from sources as varied as *Fliegende Blätter, Punch, Puck, Harper's Weekly,* Rackham's *Midsummer Night's Dream,* and the Hawtin Engraving Company Catalogue.

CONTENTS

Bibliographical Note

860 Old-Time Silhouettes, first published in 2003, is a retitled republication of *More Silhouettes: 868 Copyright-Free Illustrations for Artists and Craftsmen,* published by Dover Publications, Inc., in 1982.

DOVER *Pictorial Archive* SERIES

Library of Congress Cataloging-in-Publication Data

Main entry under the title: More Silhouettes.
 ISBN 0-486-24256-0 (pbk.)
 1. Silhouettes. I. Grafton, Carol Belanger.

NC910.M65
741.7
 81-17361
 AACR2

Manufactured in the United States of America
Dover Publications, Inc., 31 East 2nd Street, Mineola, N.Y. 11501

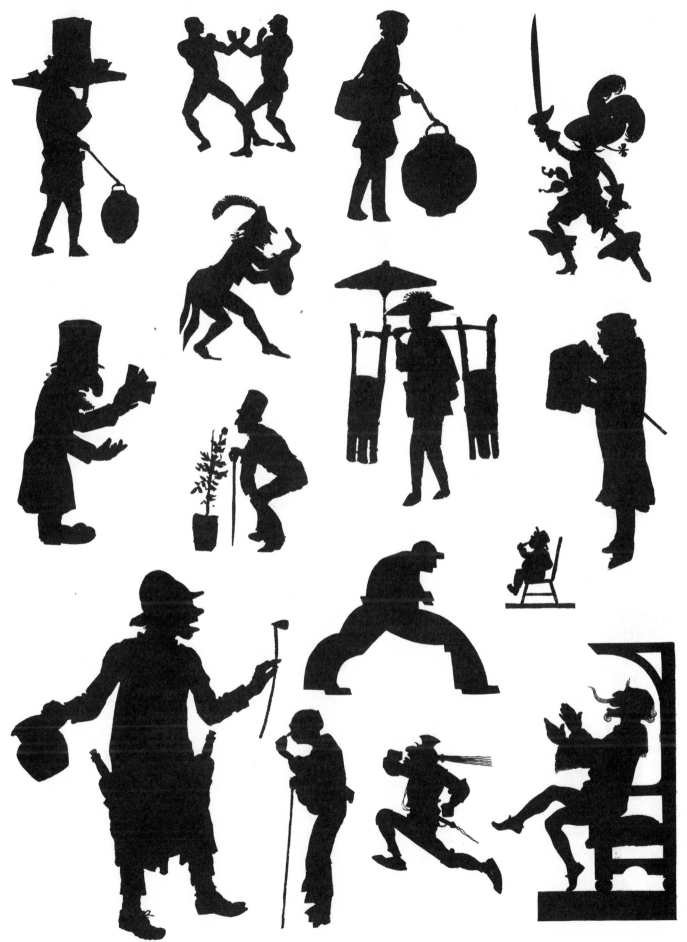

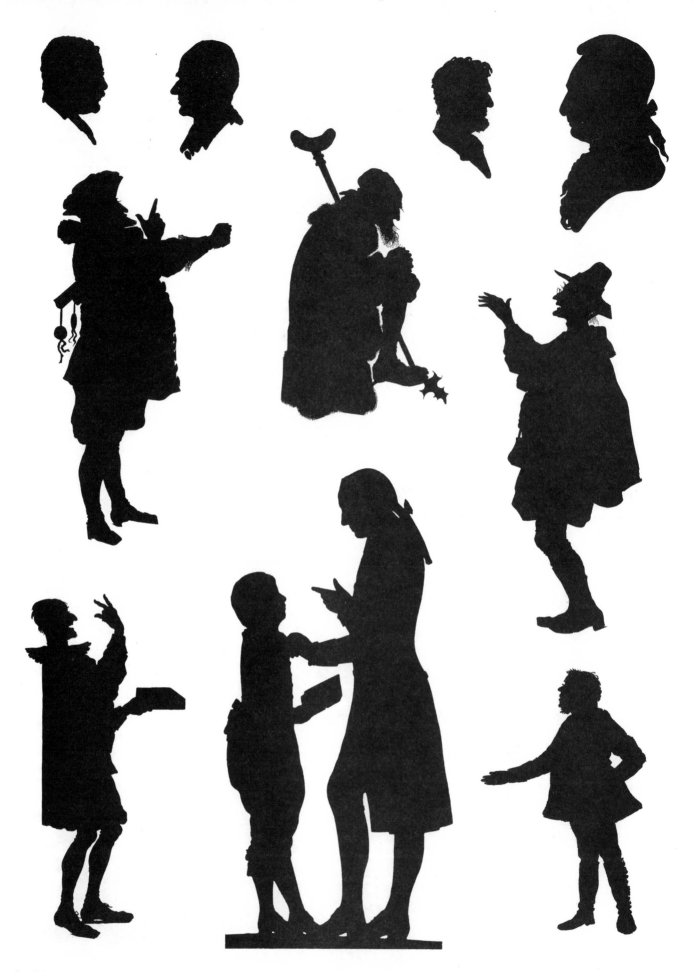

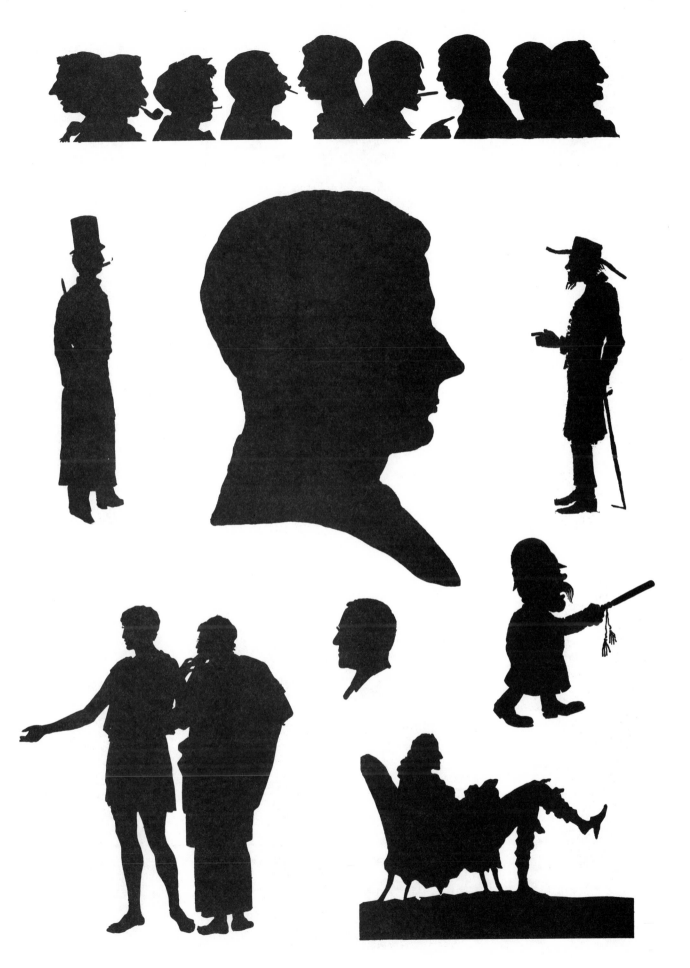

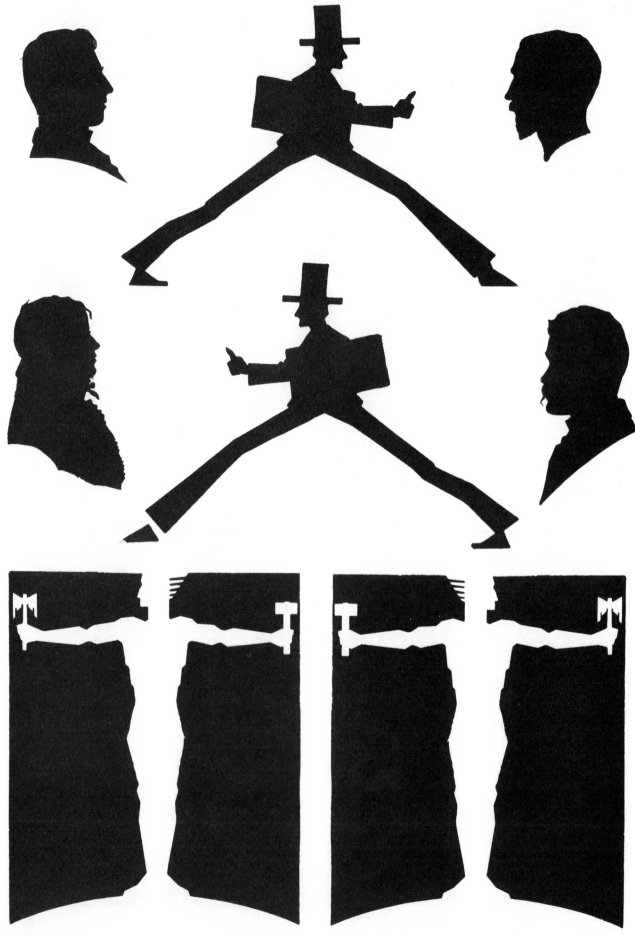

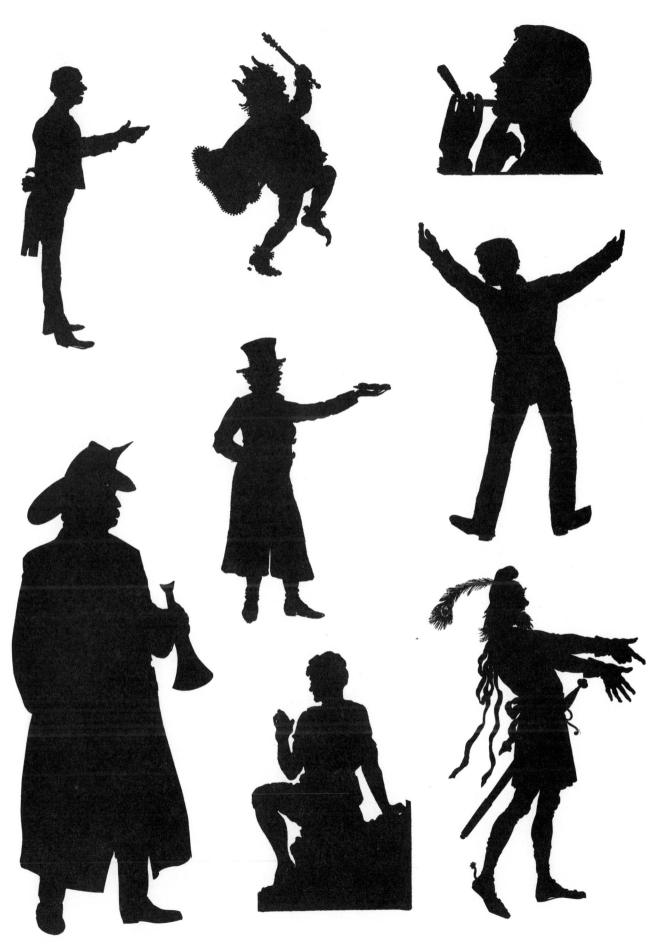

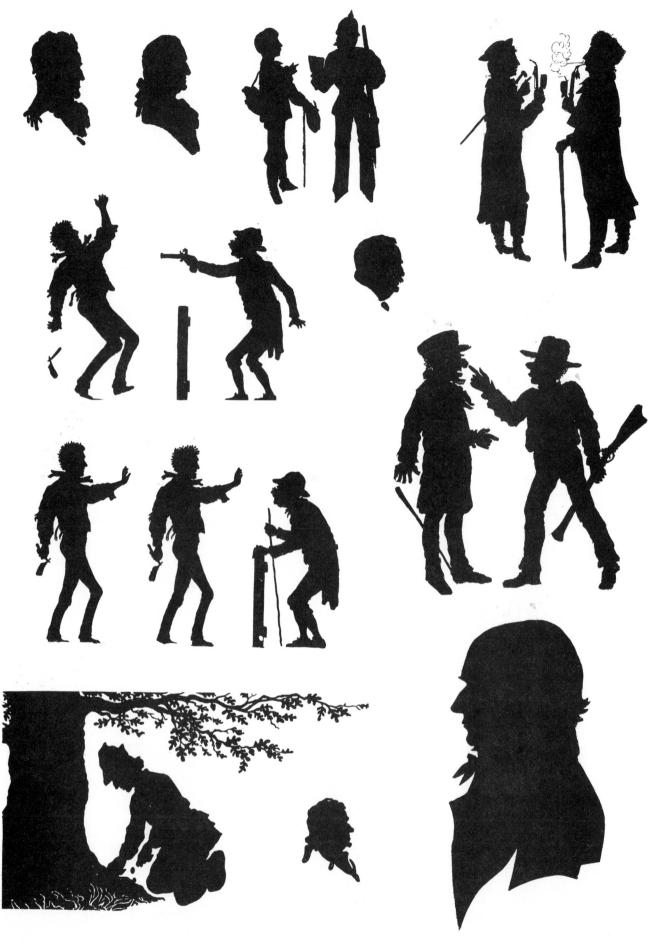

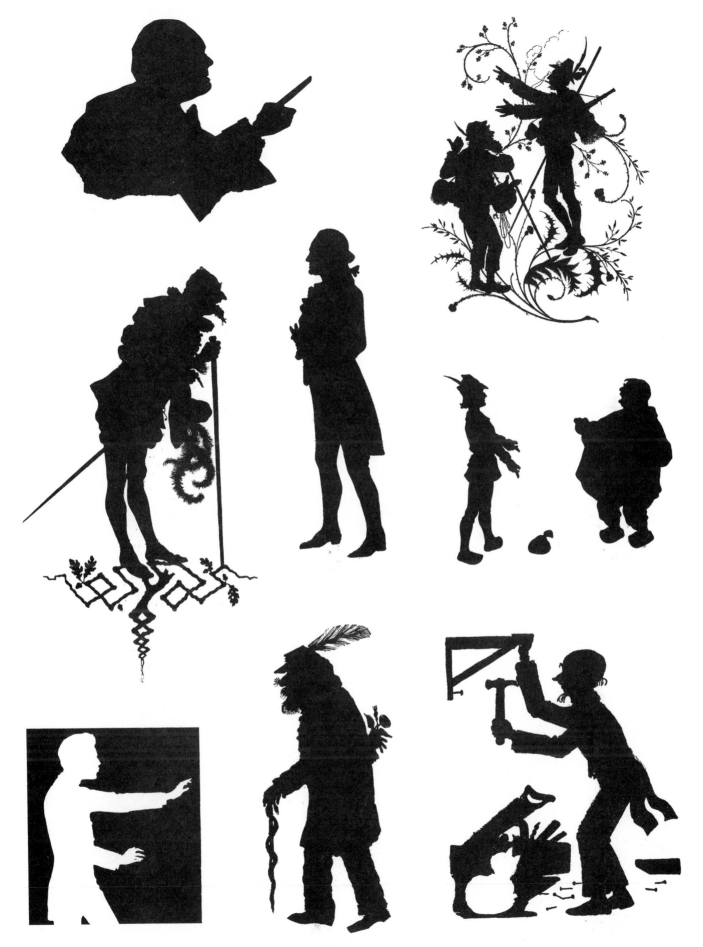

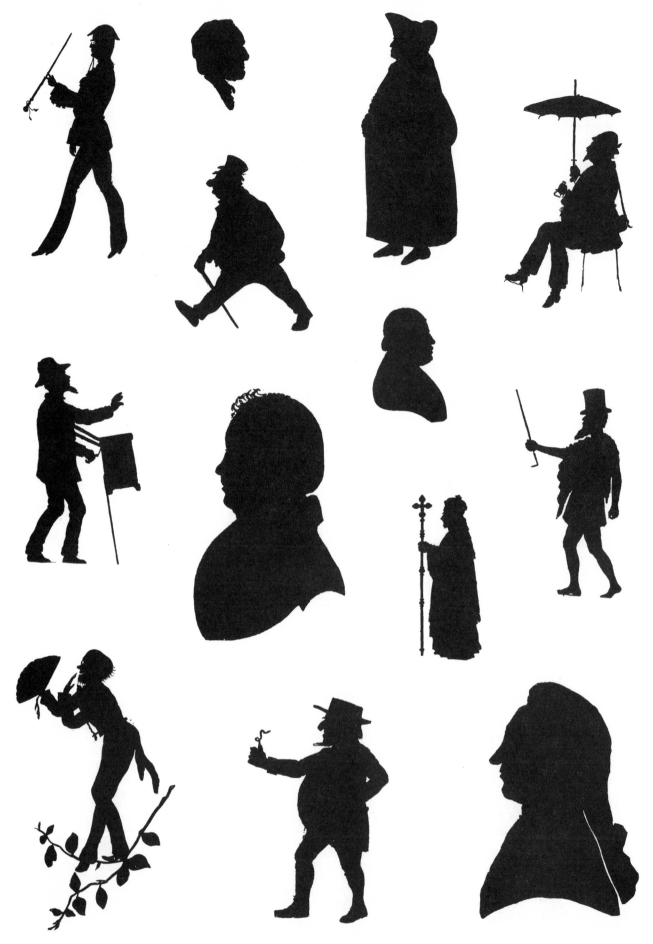

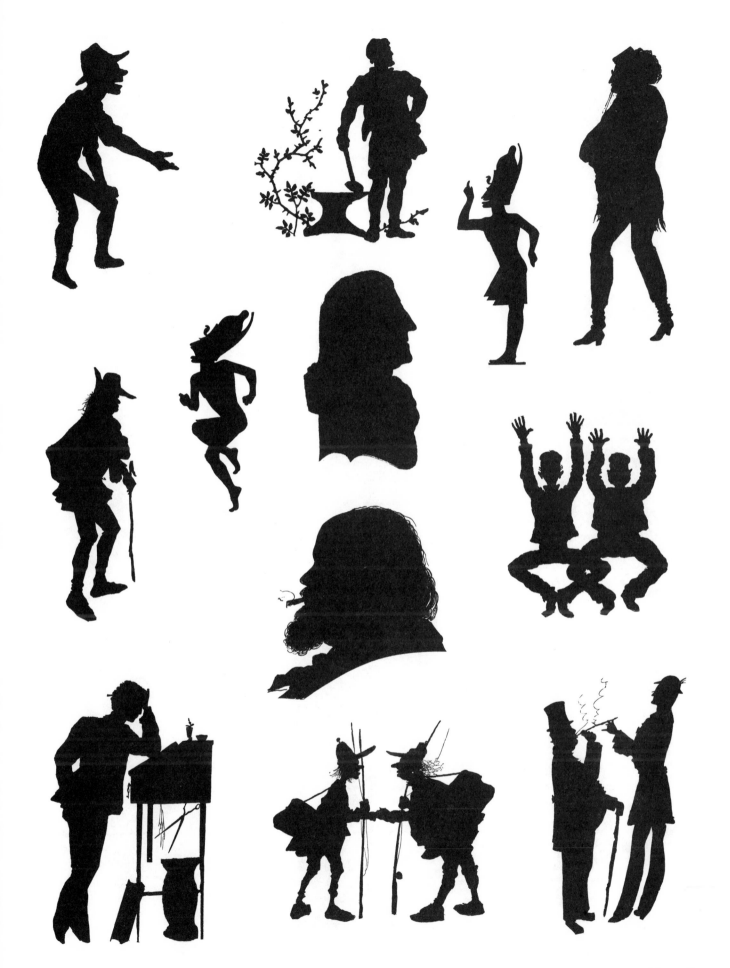

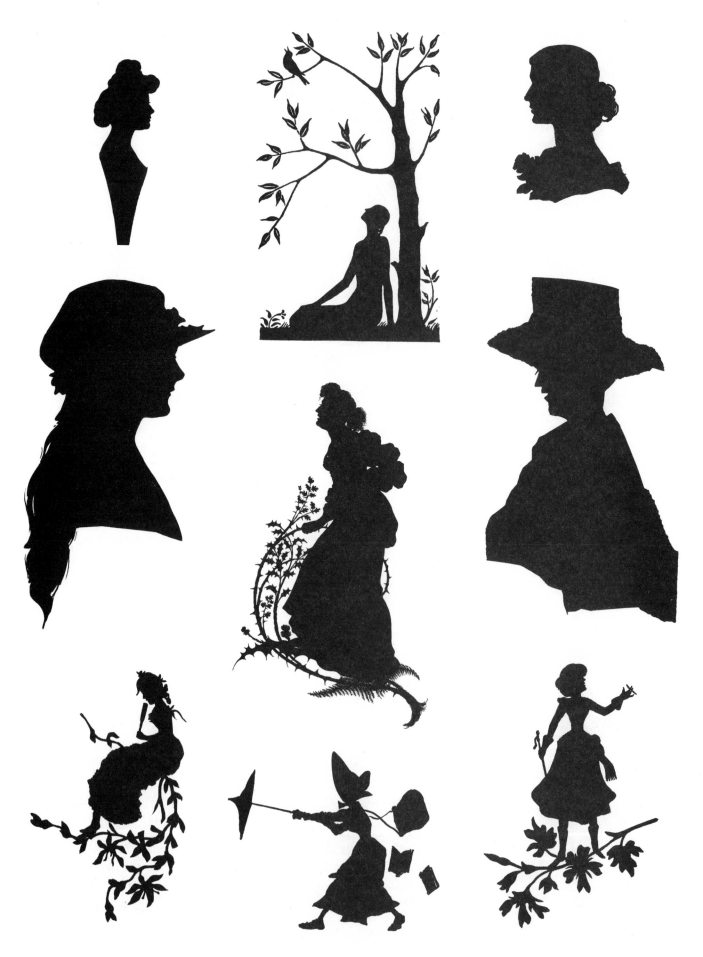

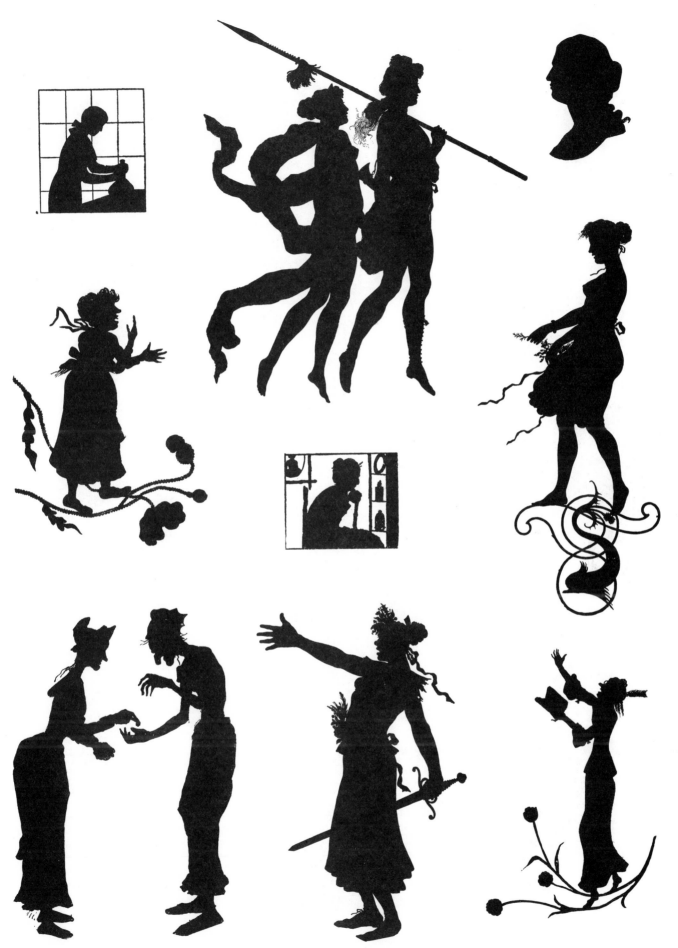

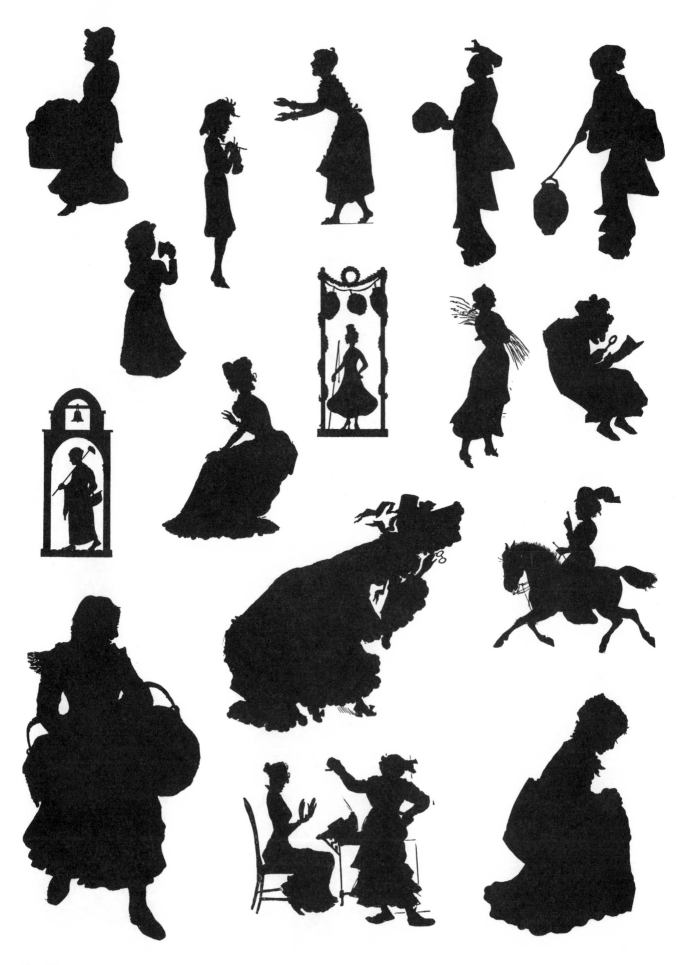

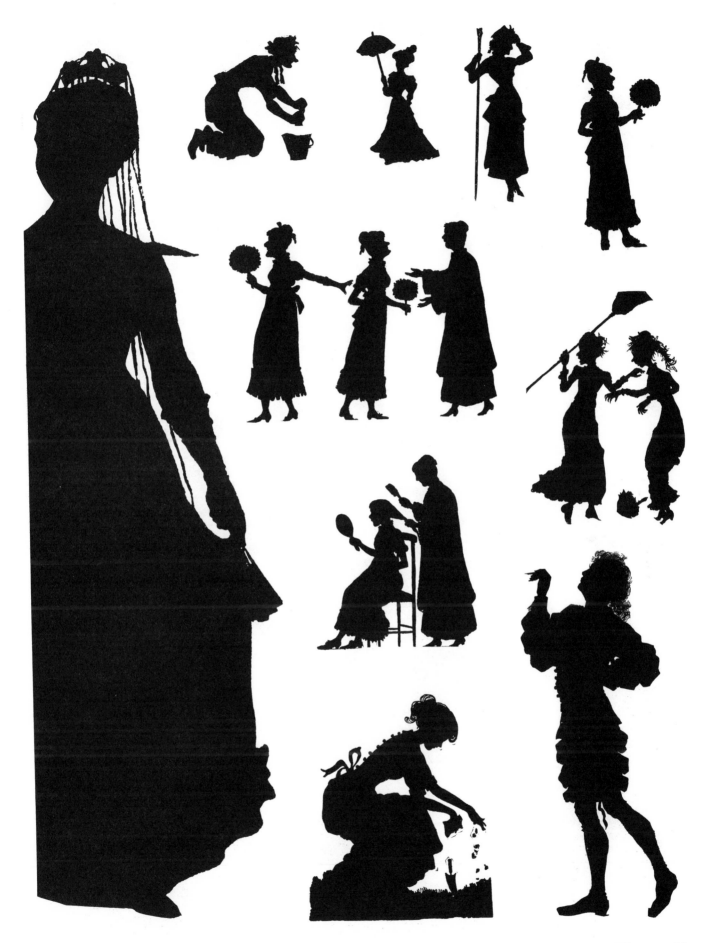

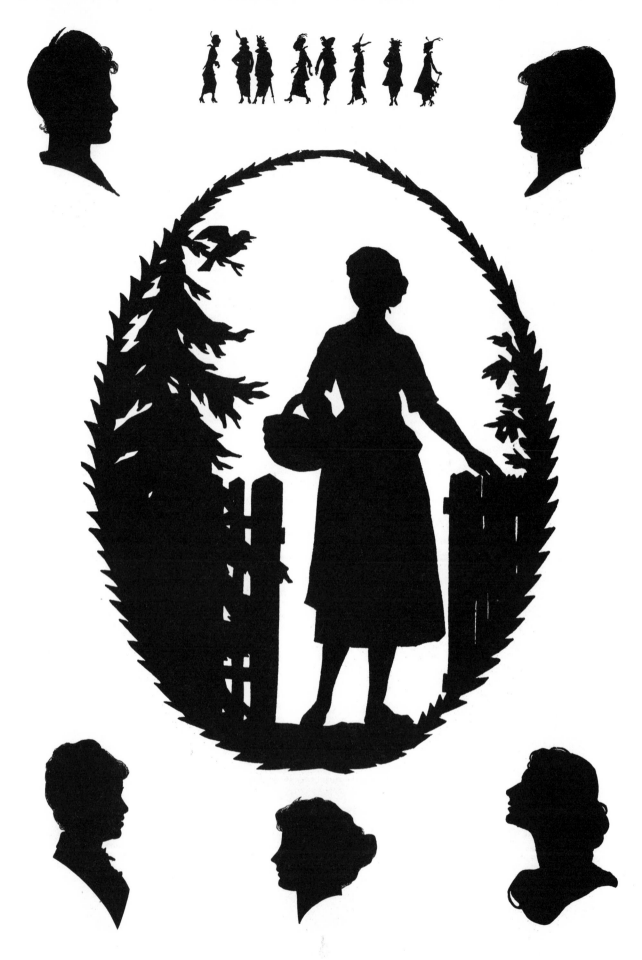

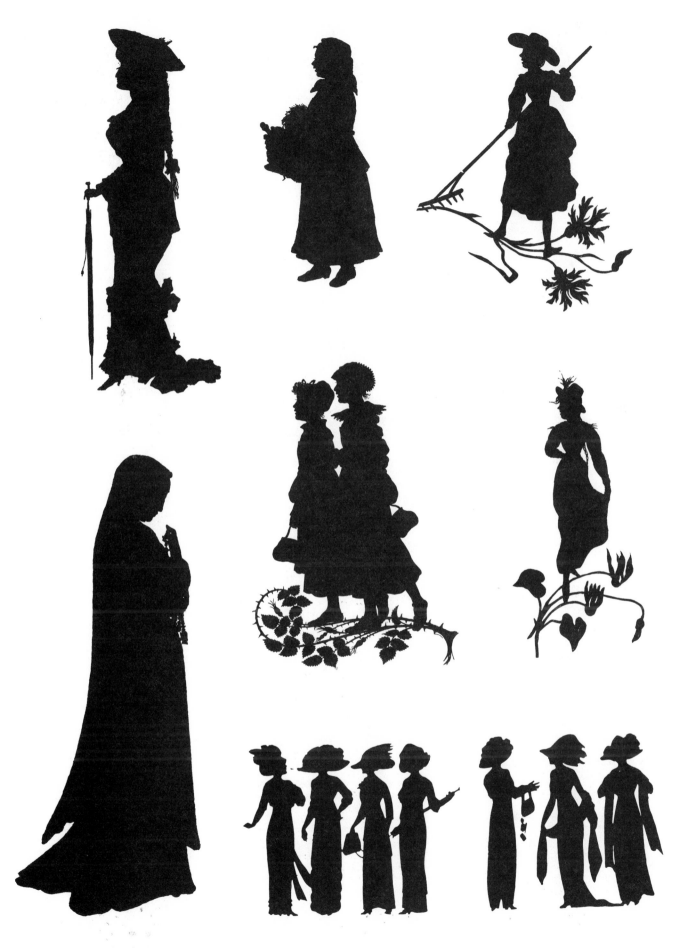

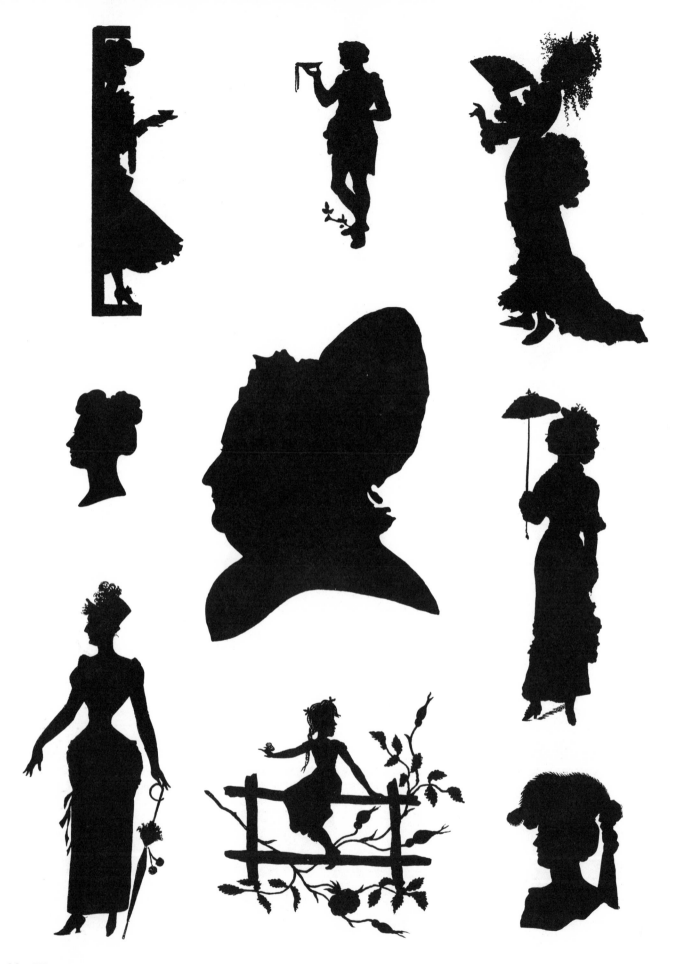

16　Women

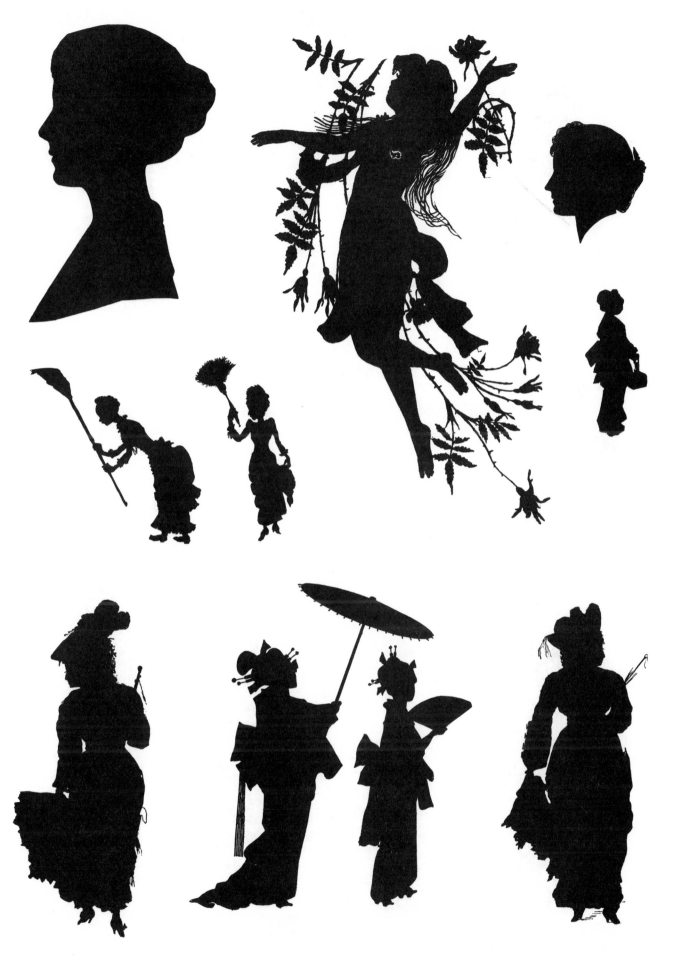

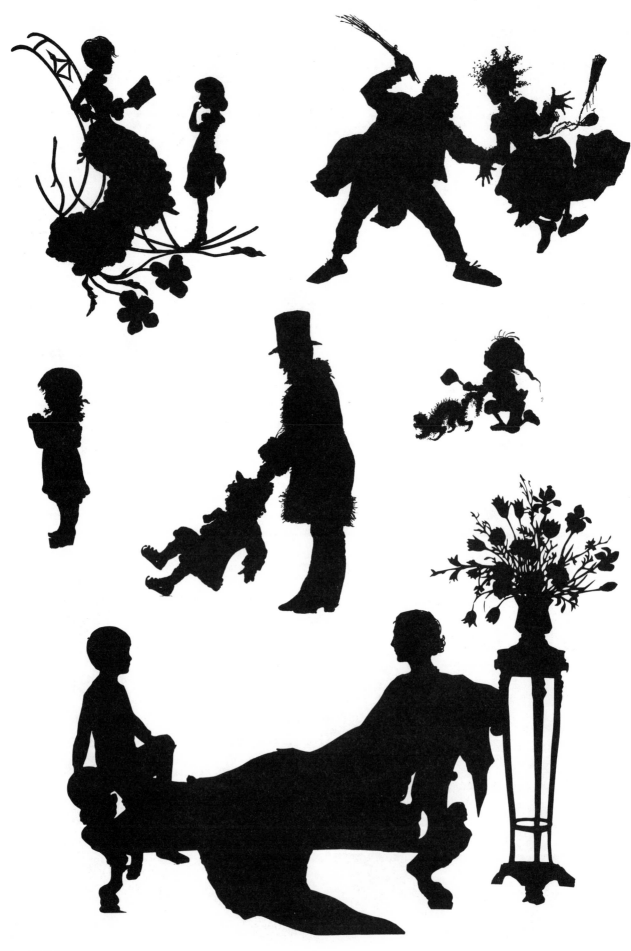

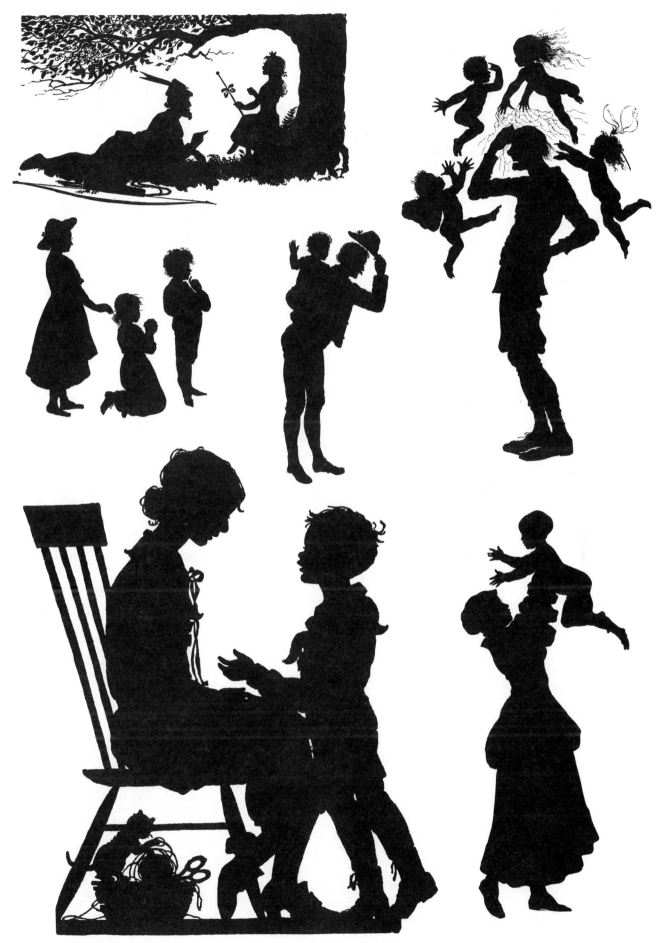

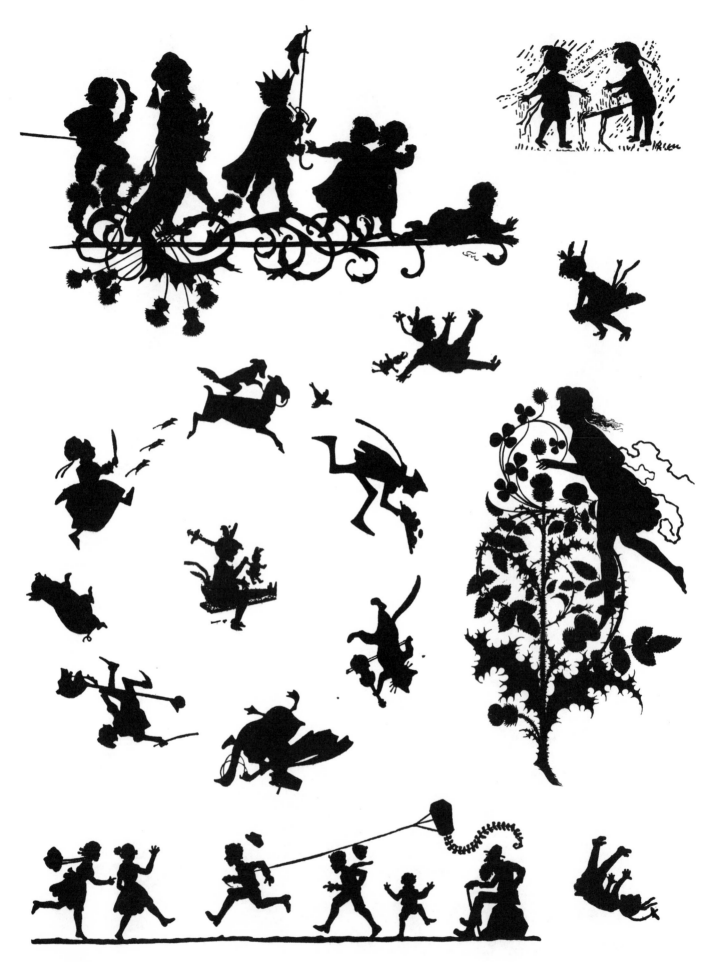

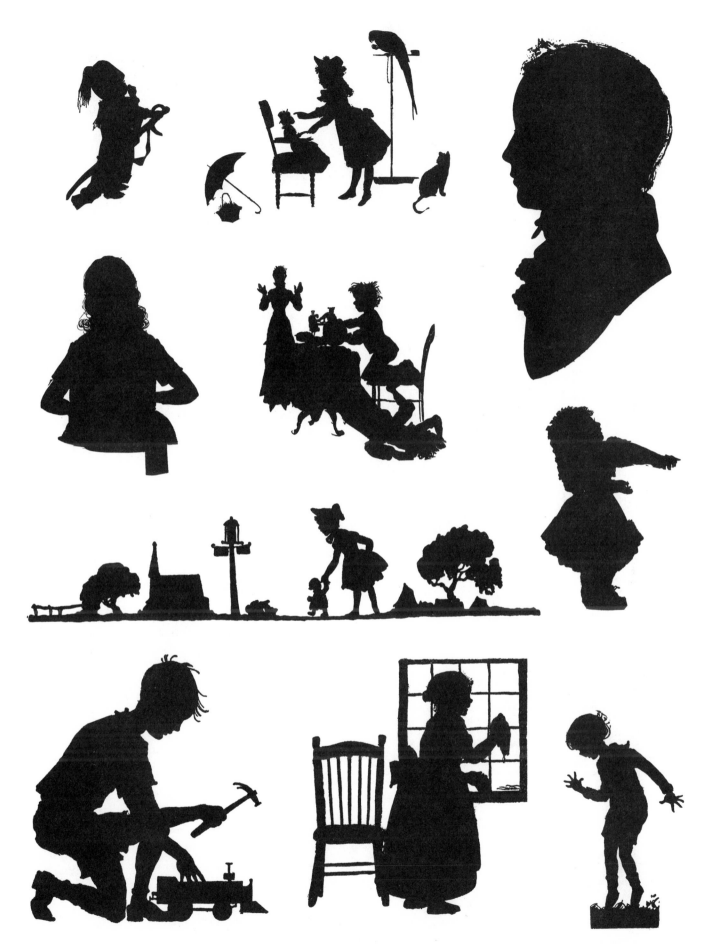

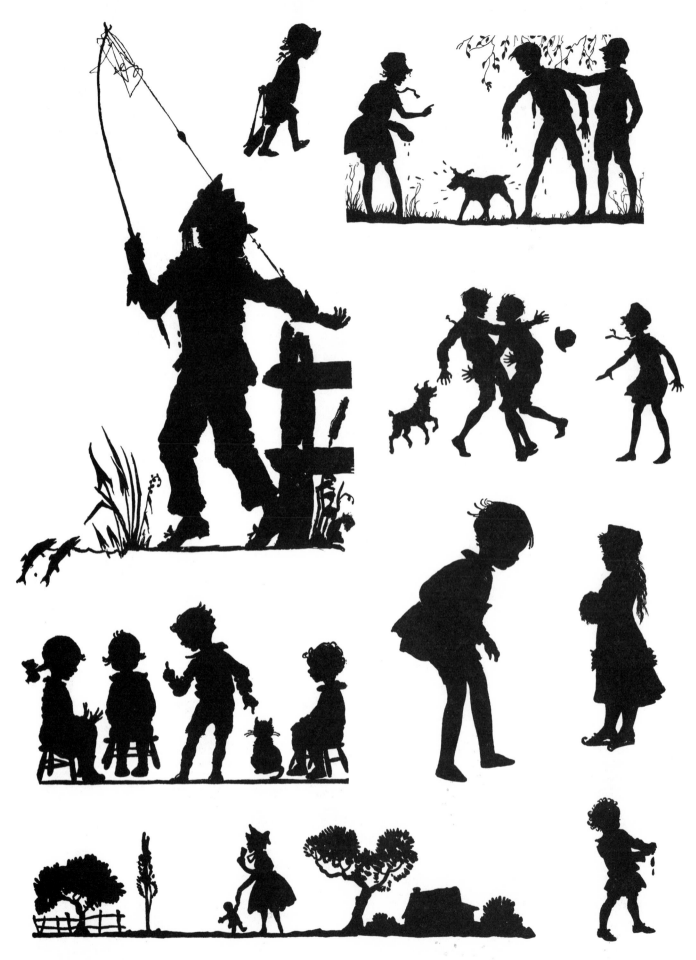

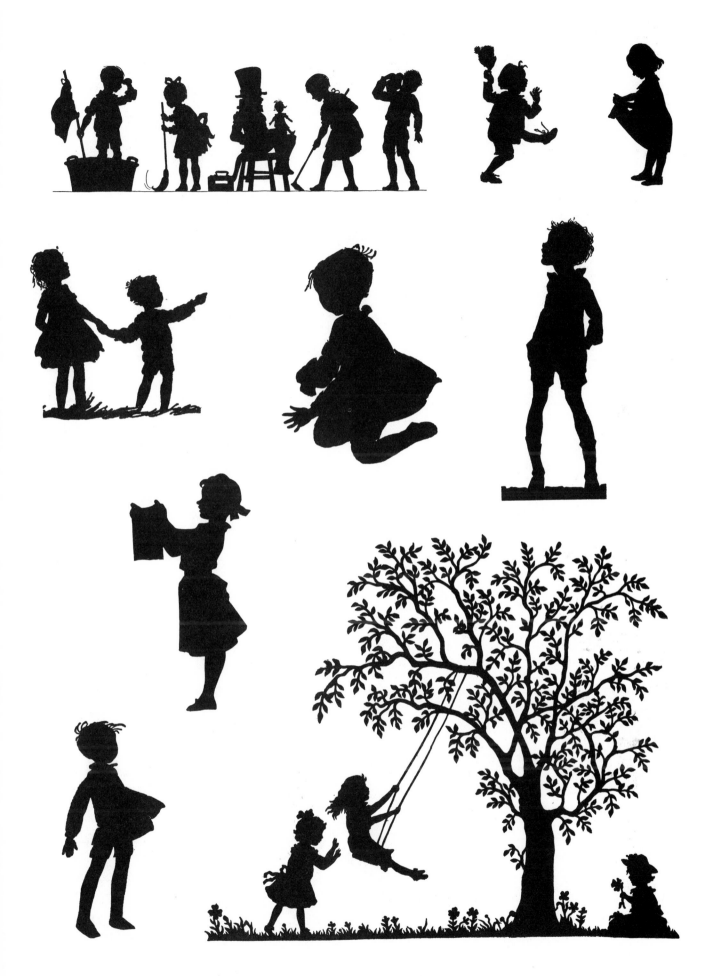

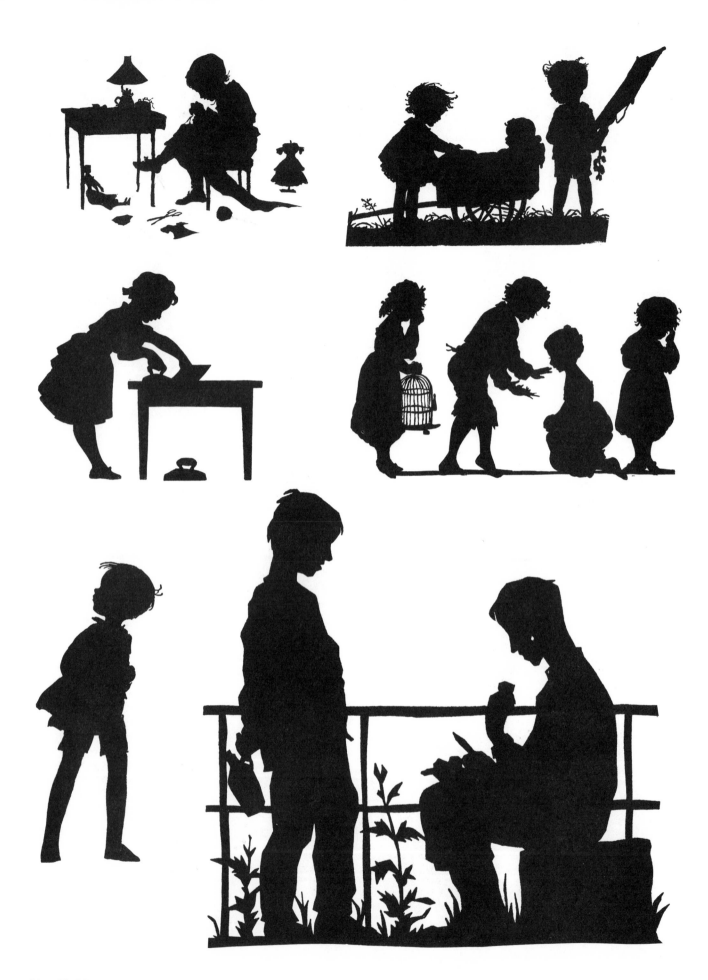

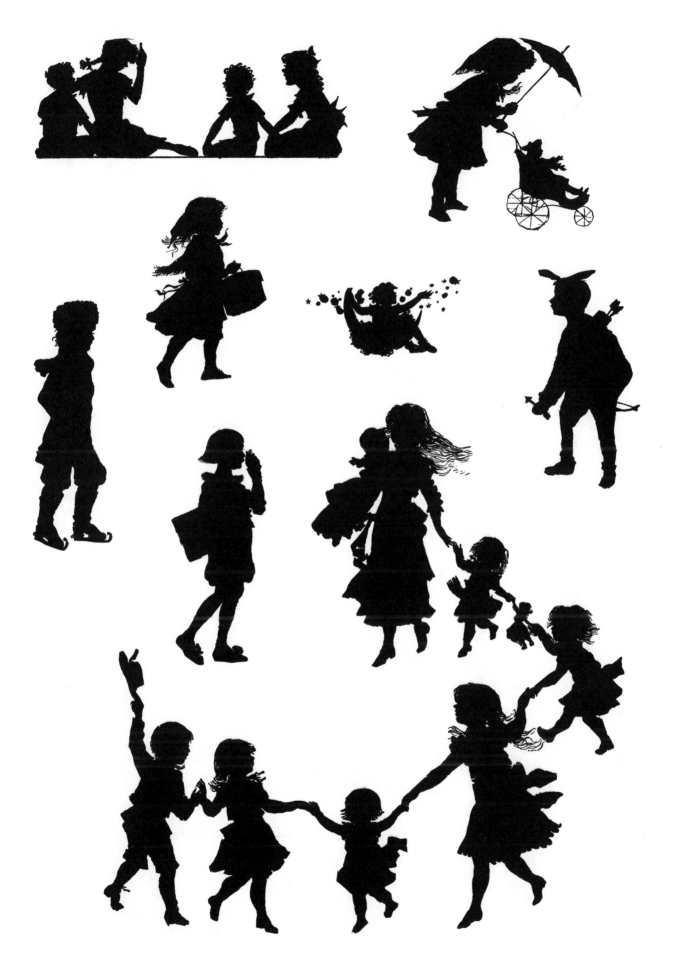

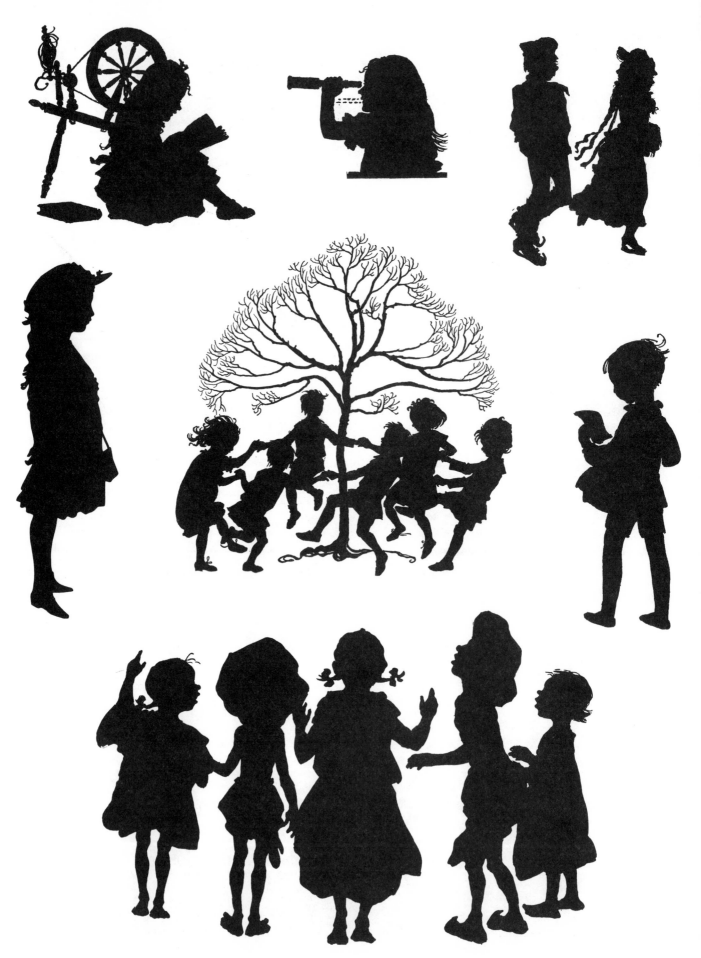

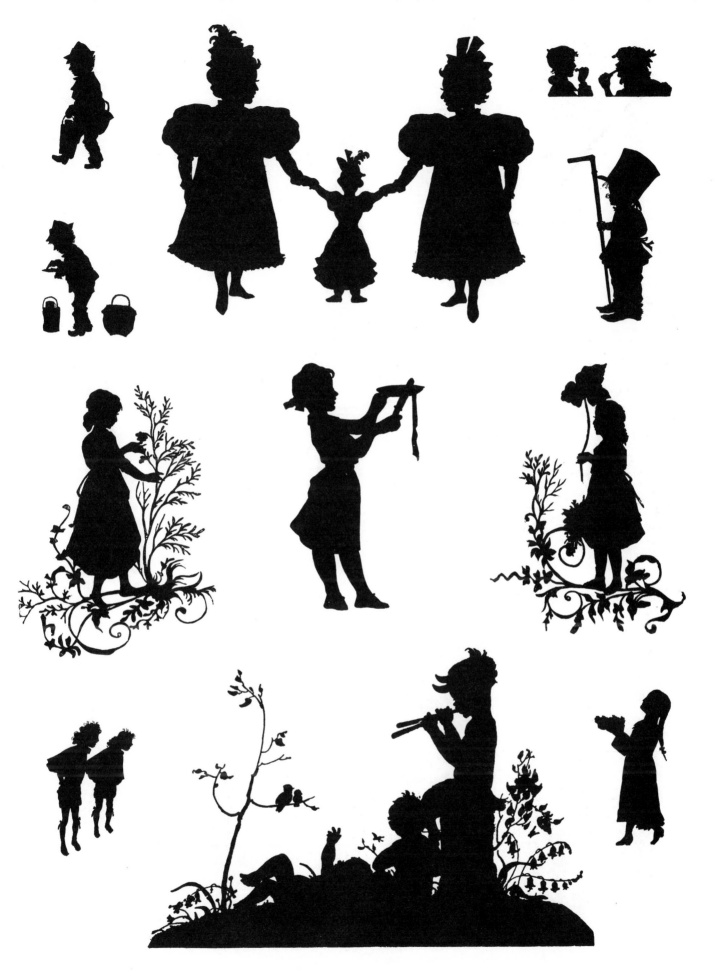

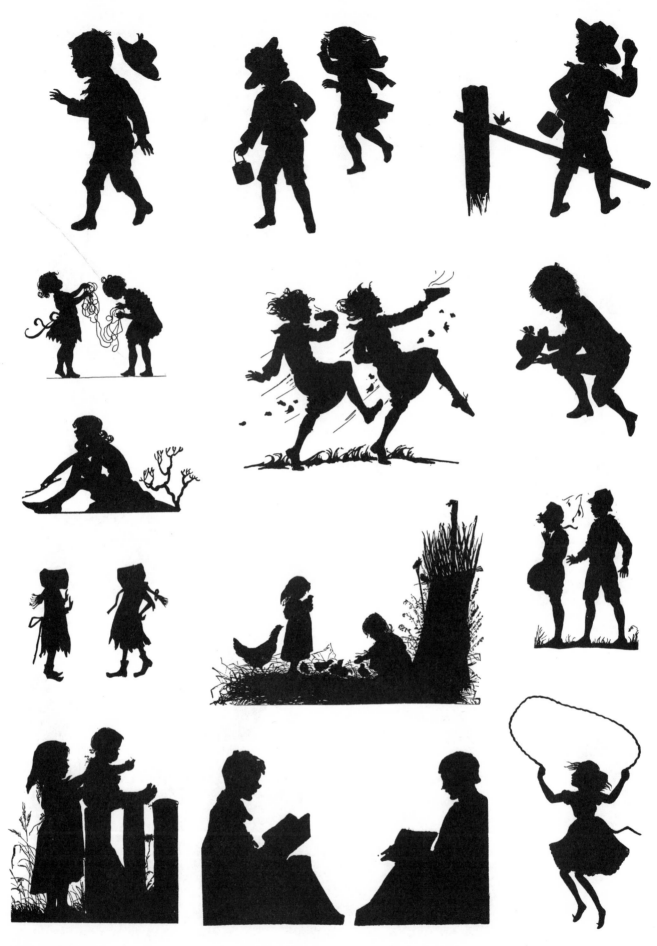

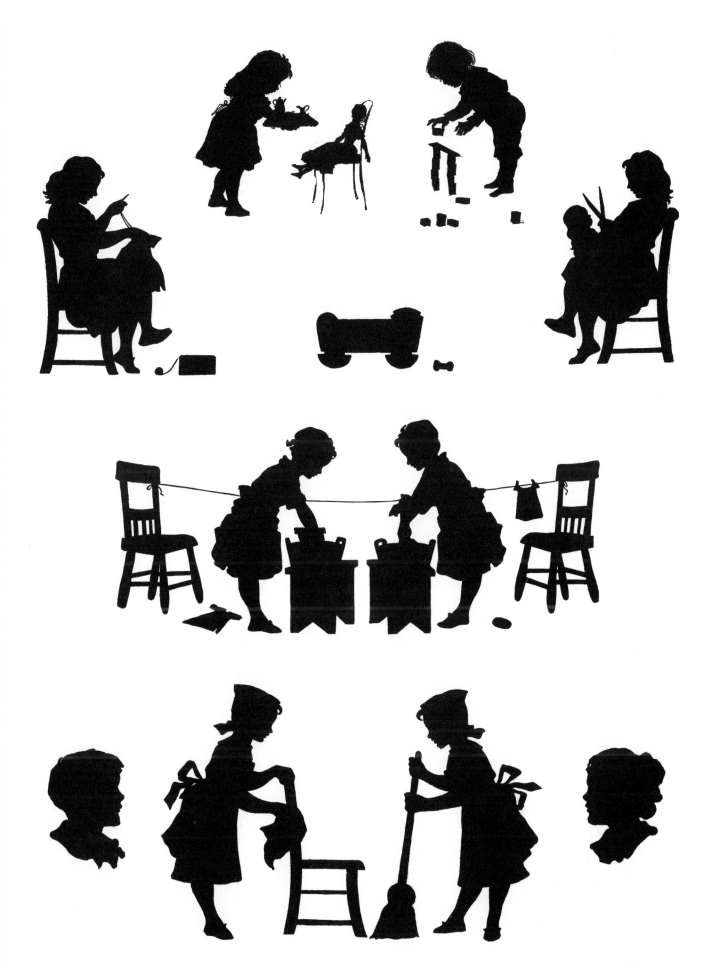

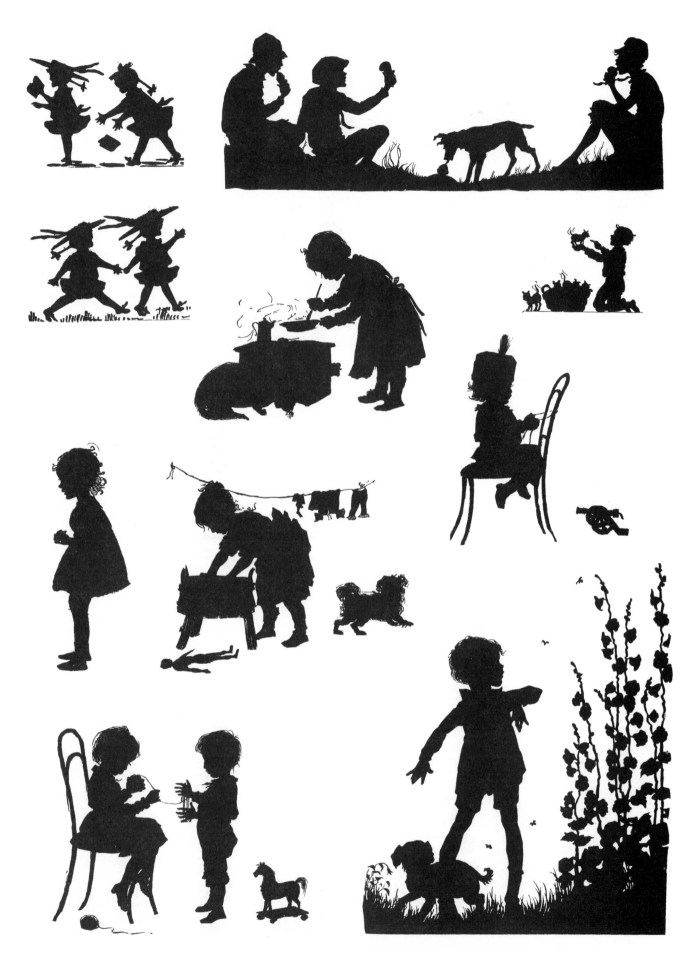

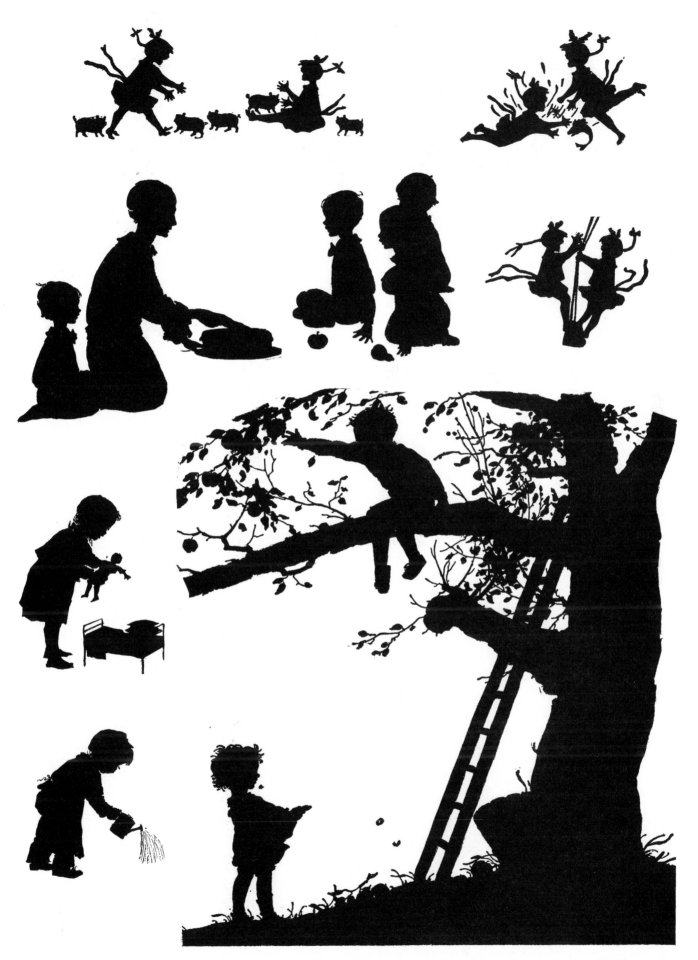

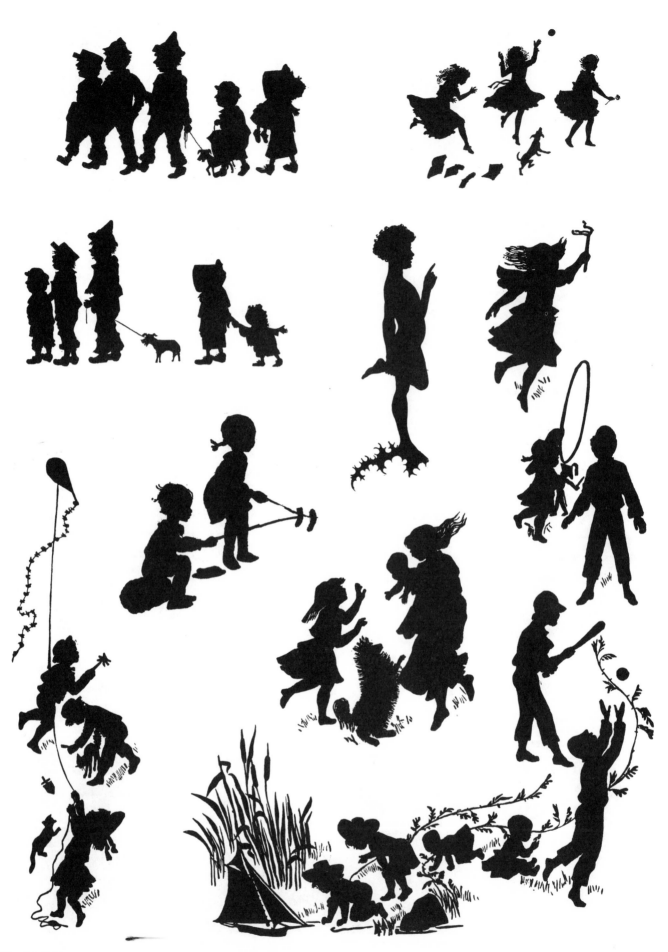

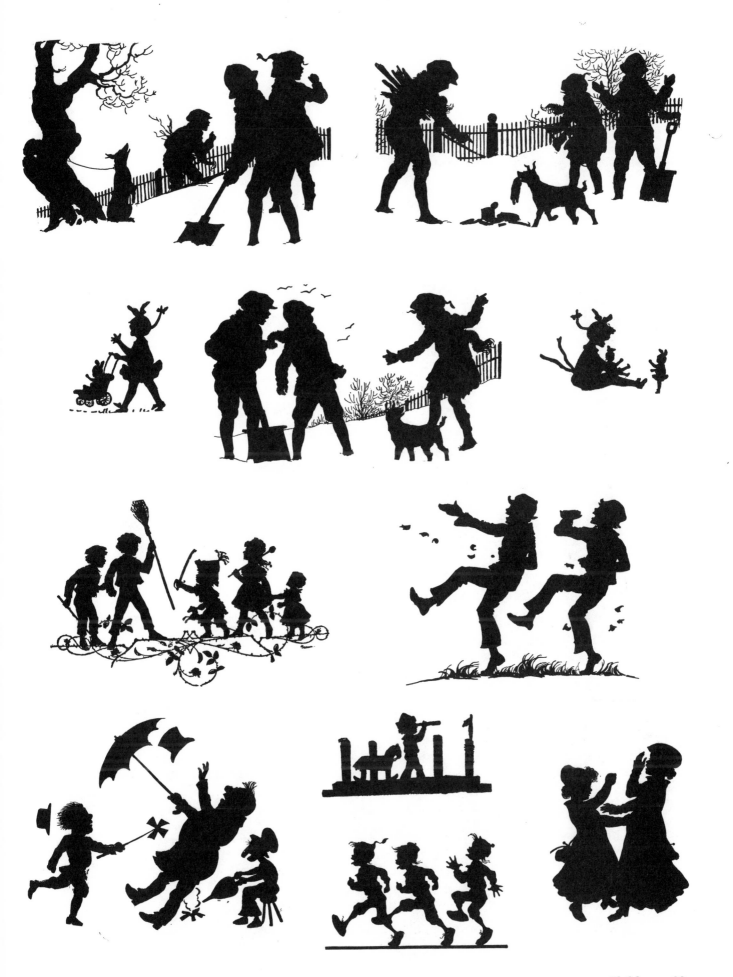

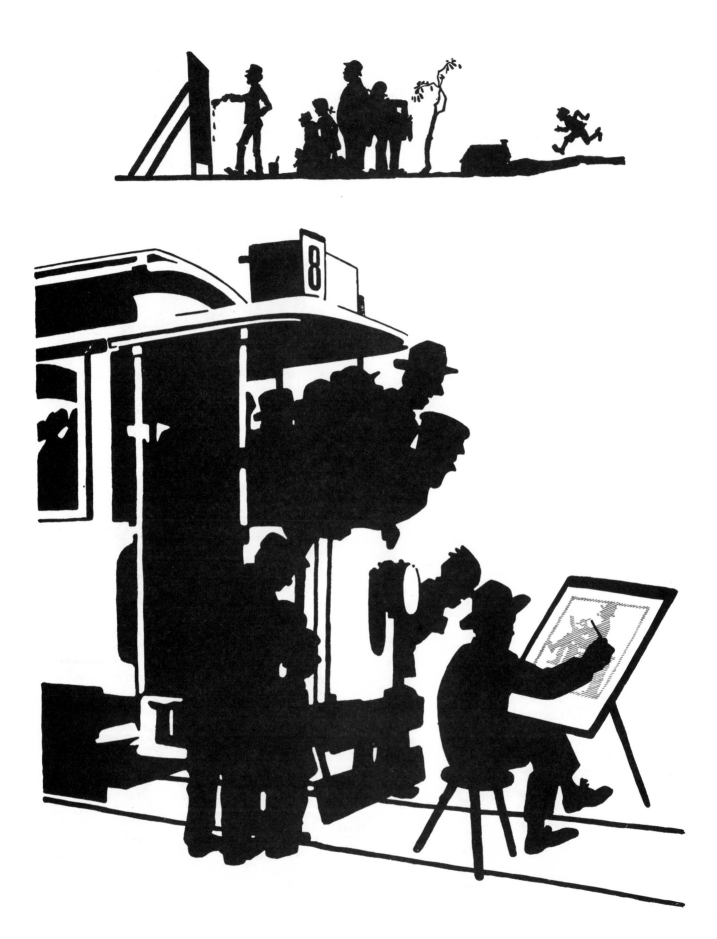

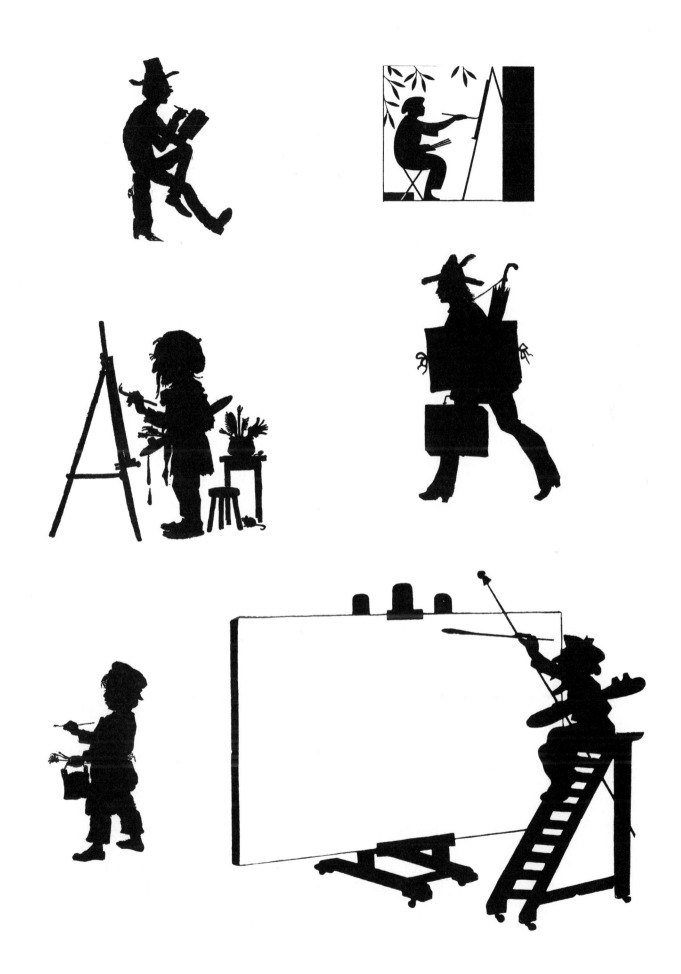

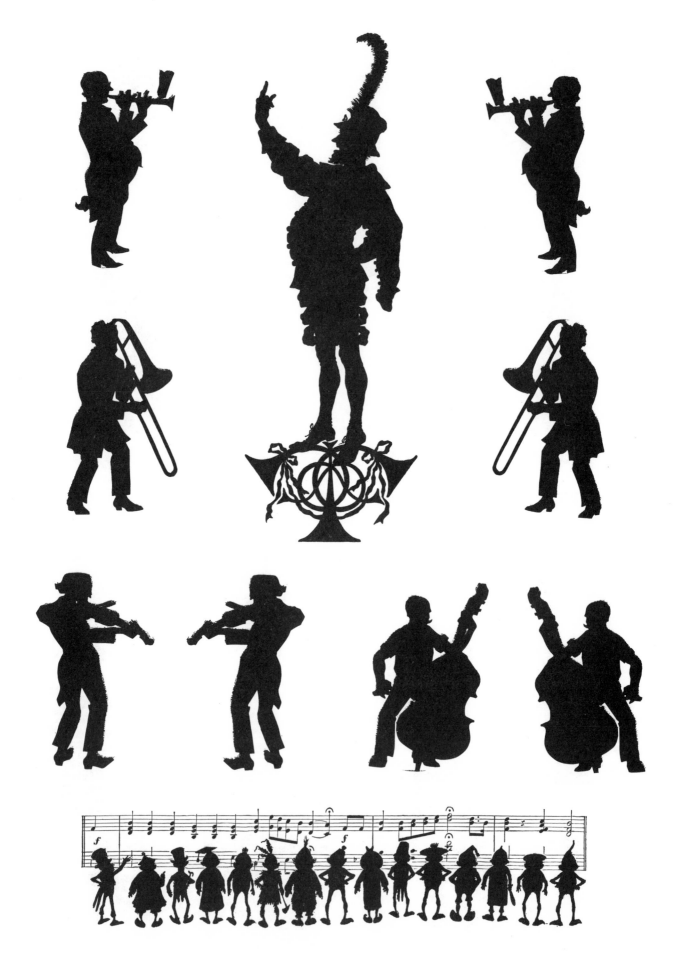

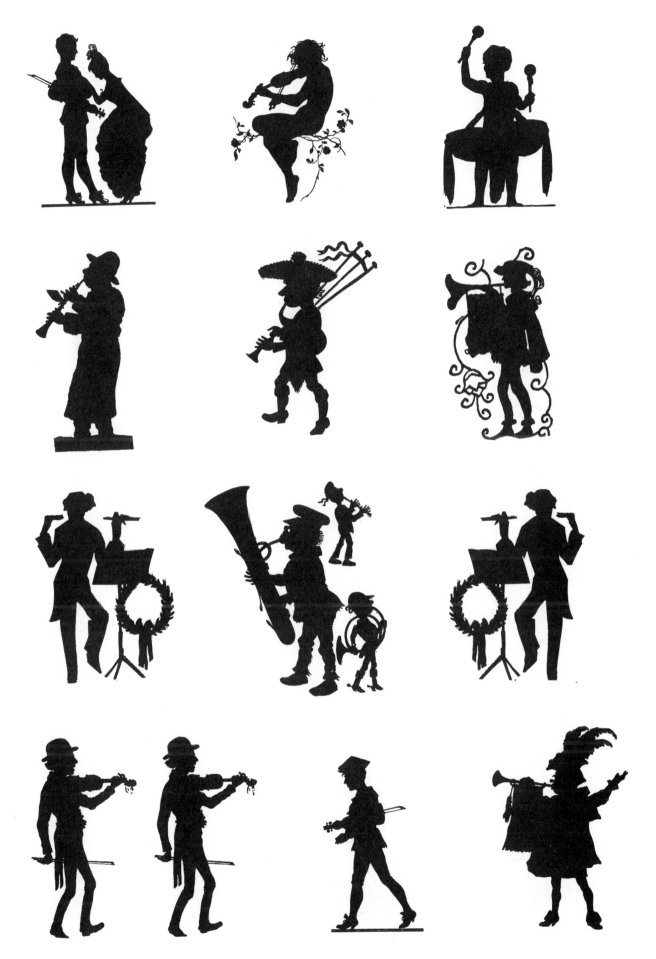

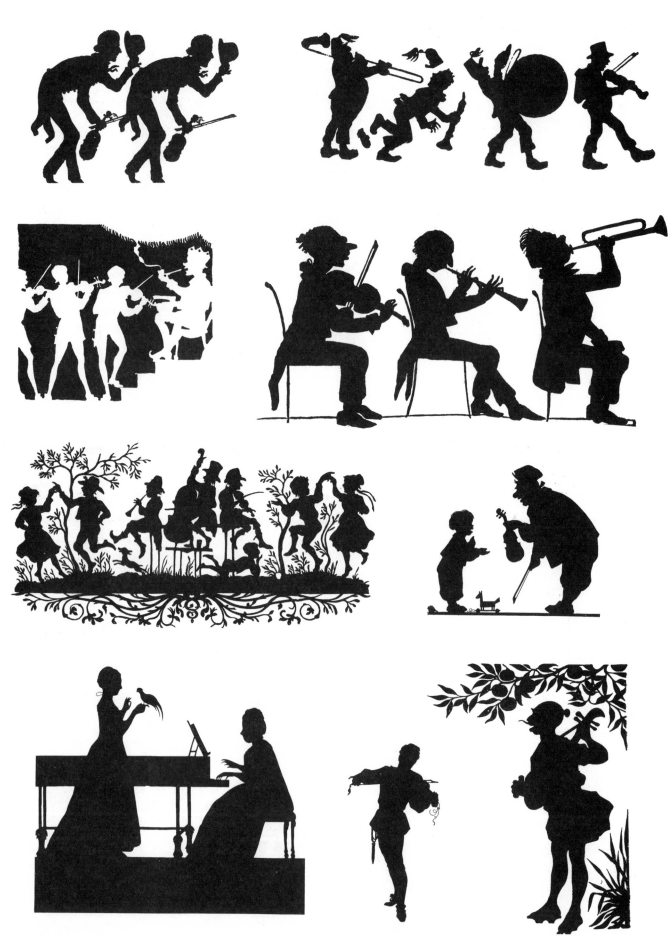

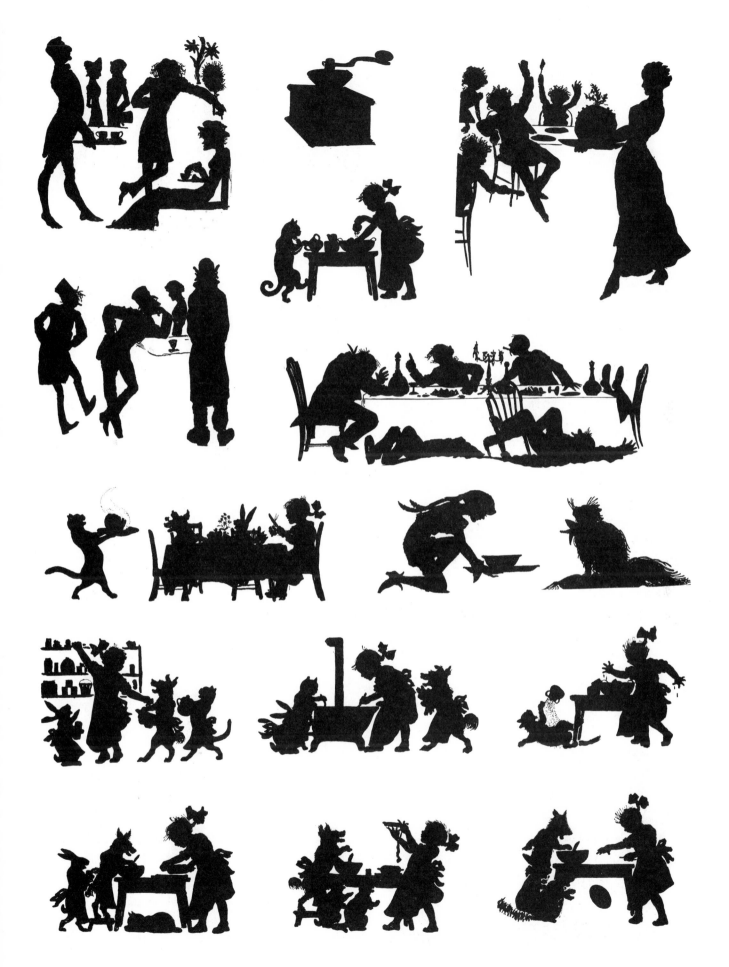

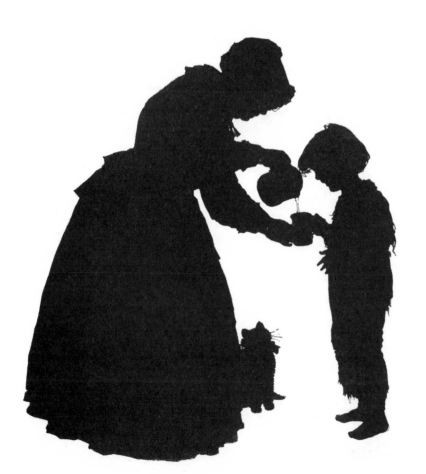

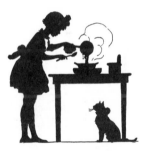

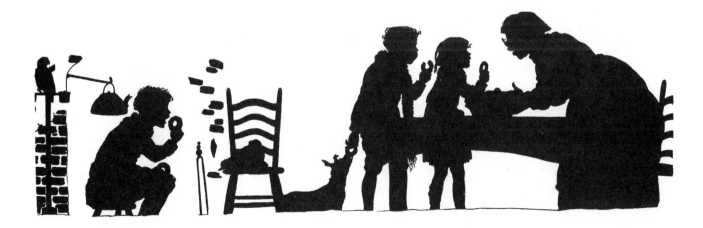

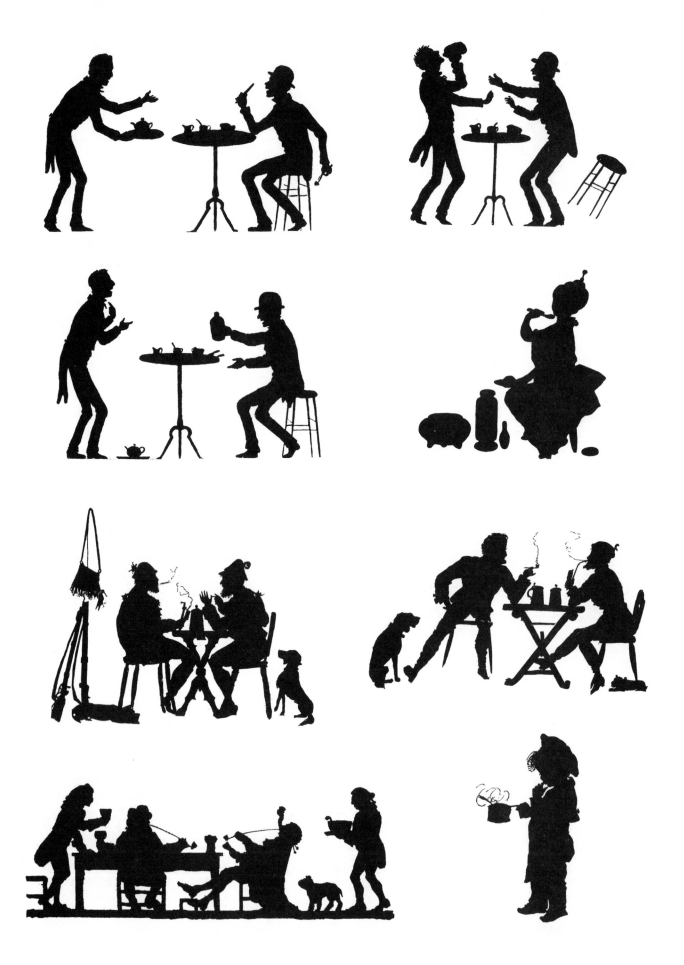

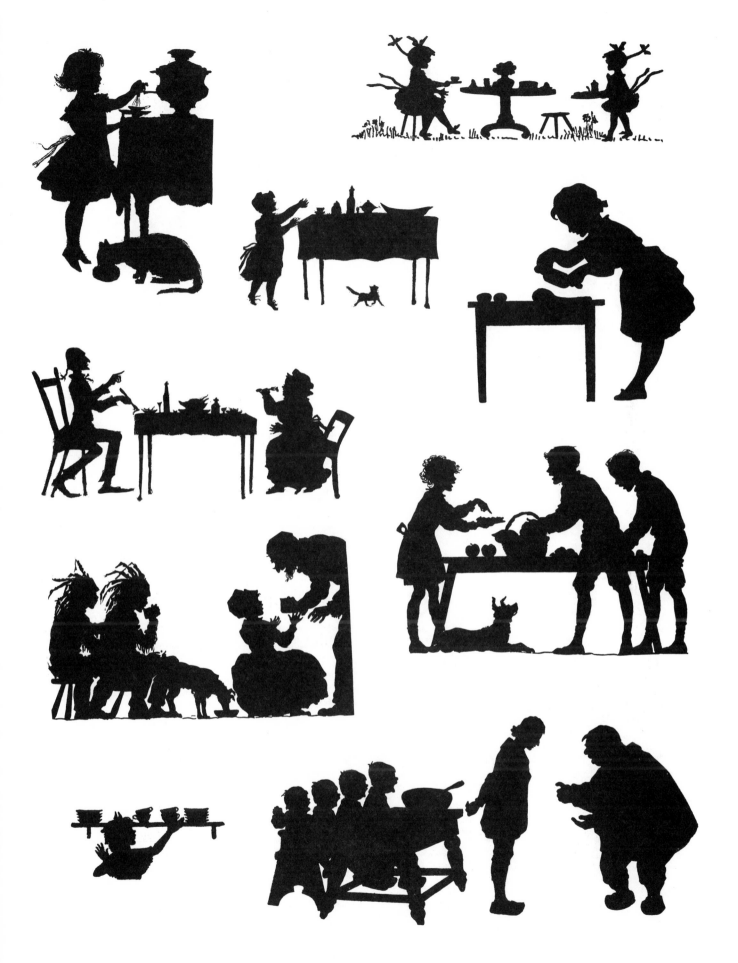

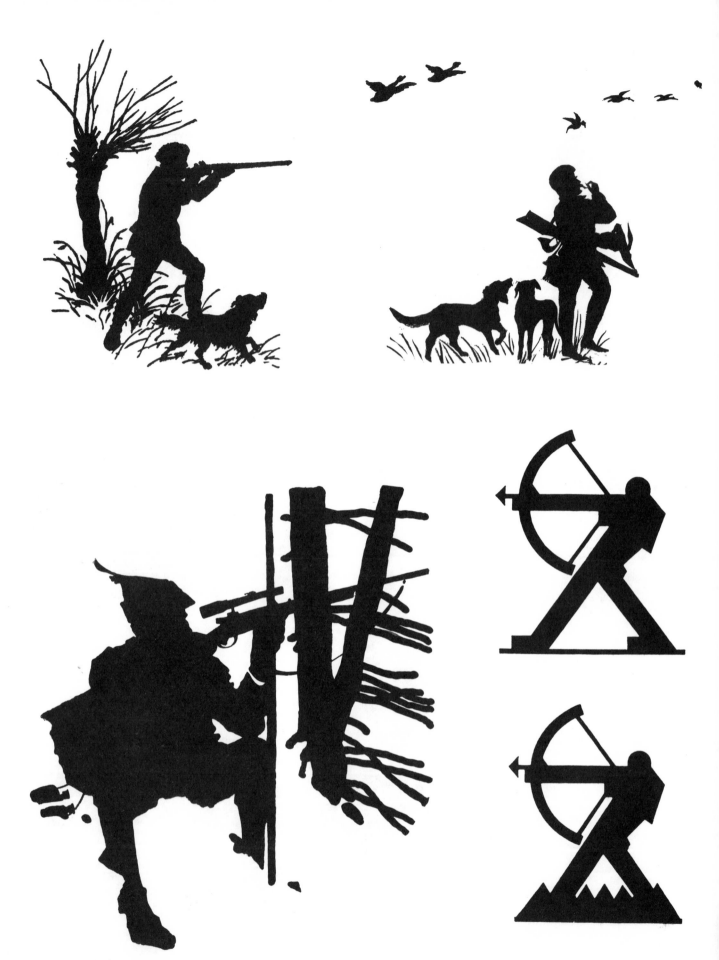

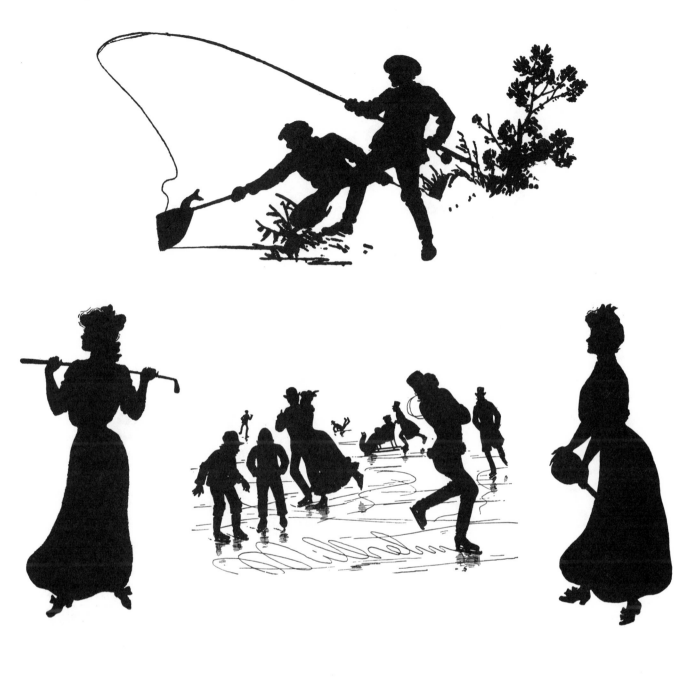

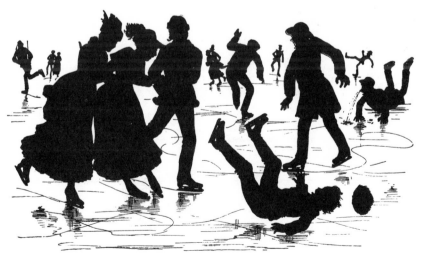

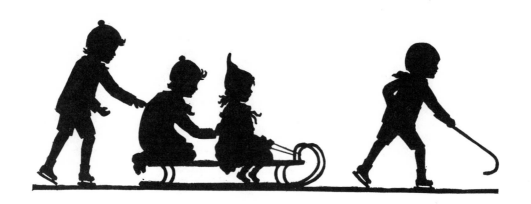

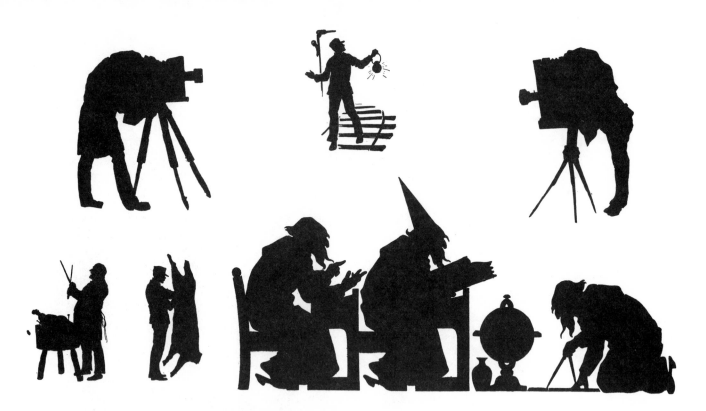

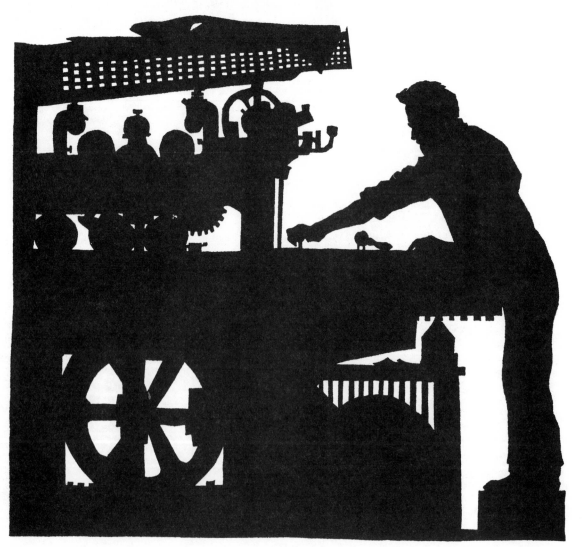

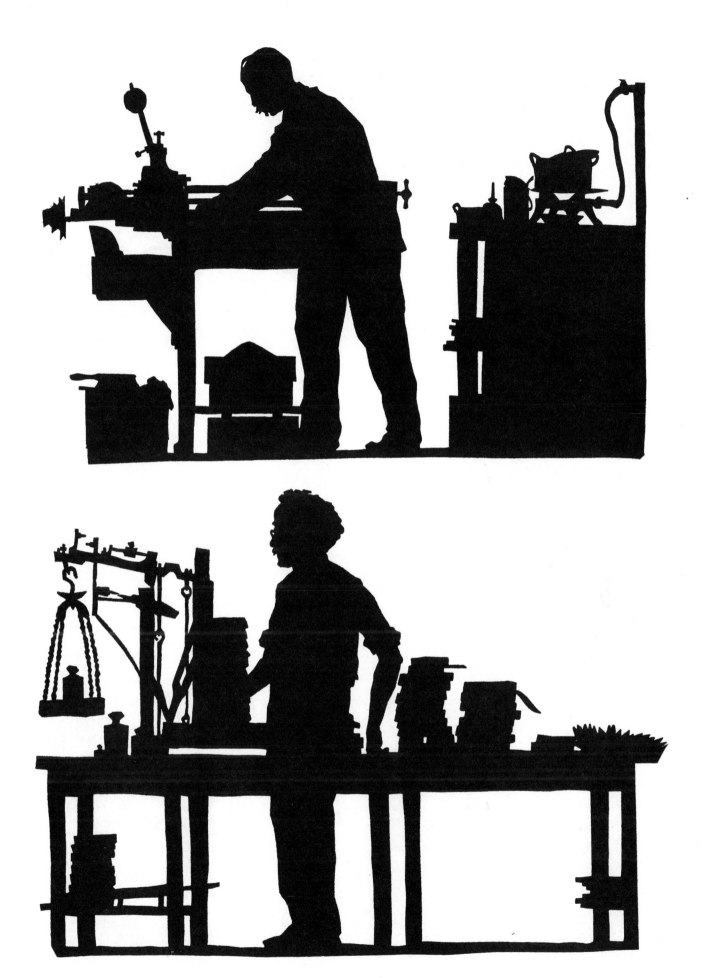

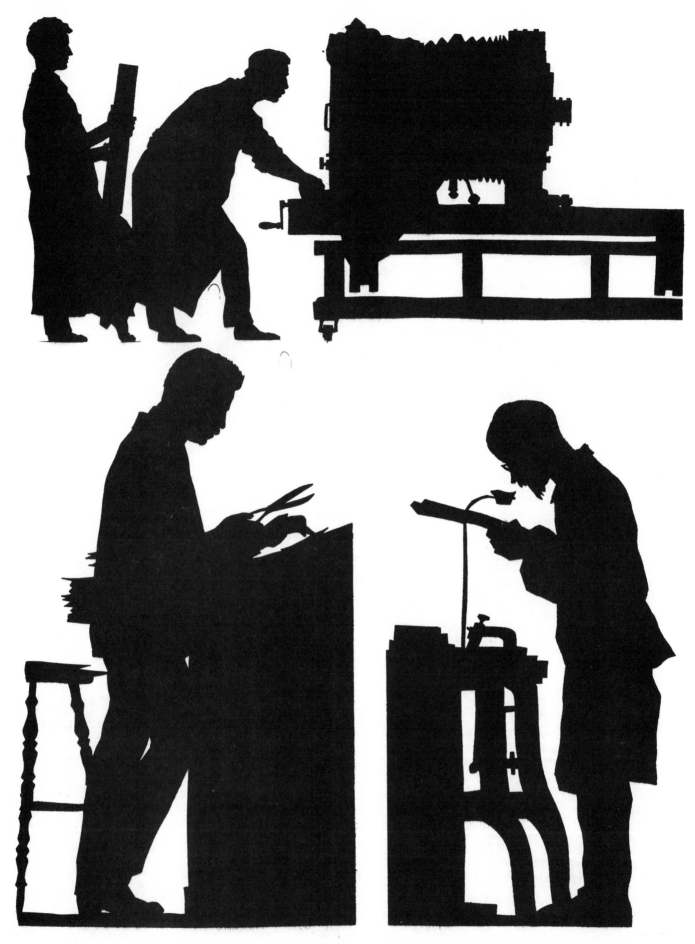

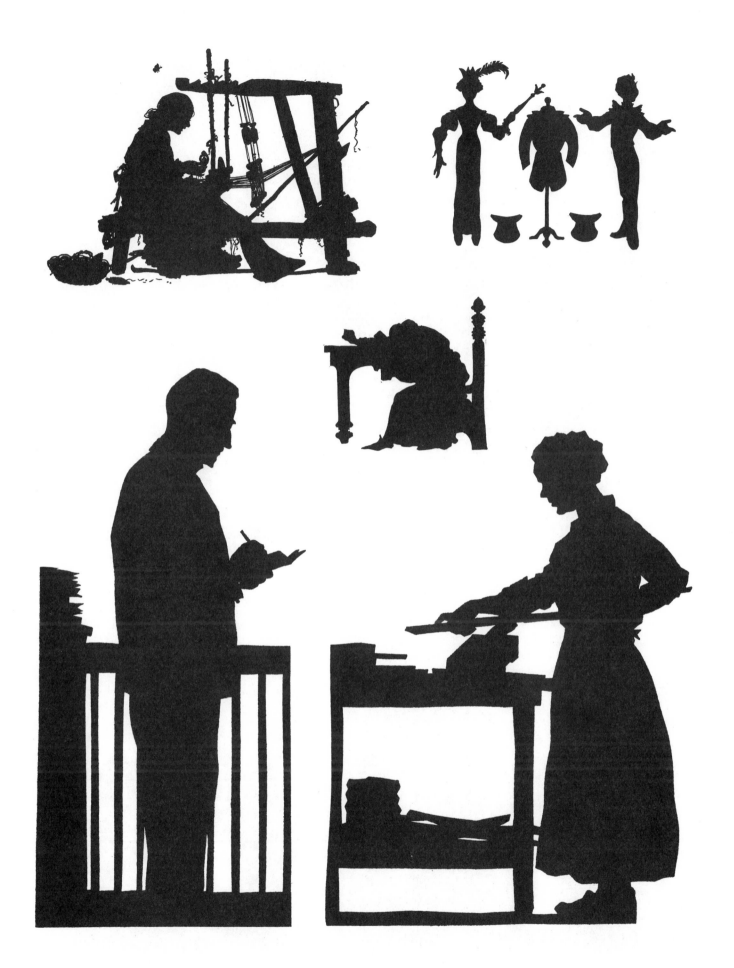

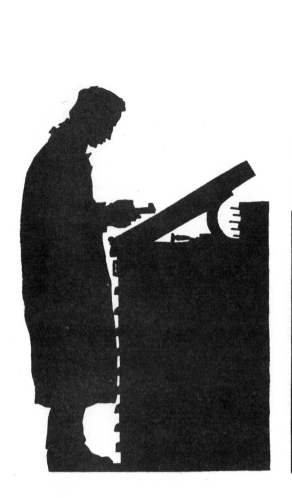
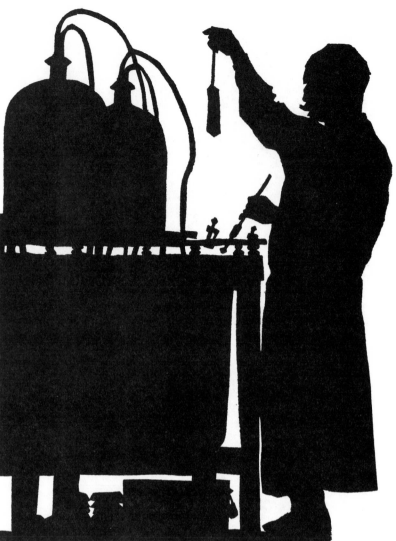
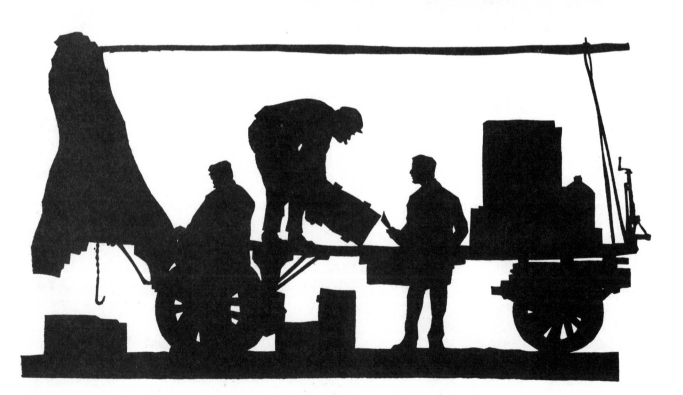

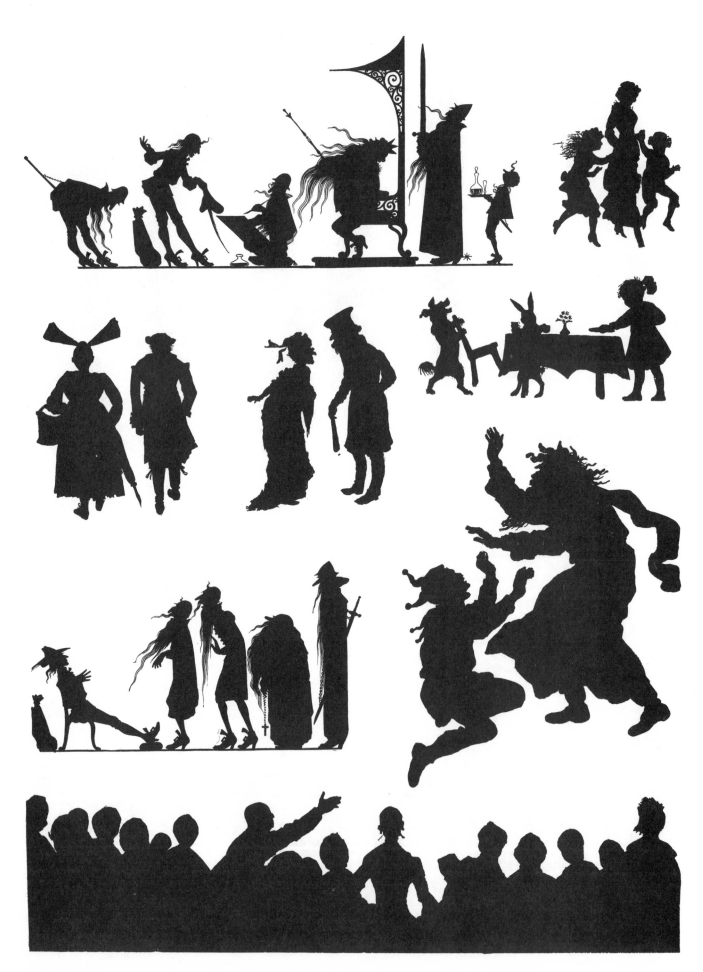

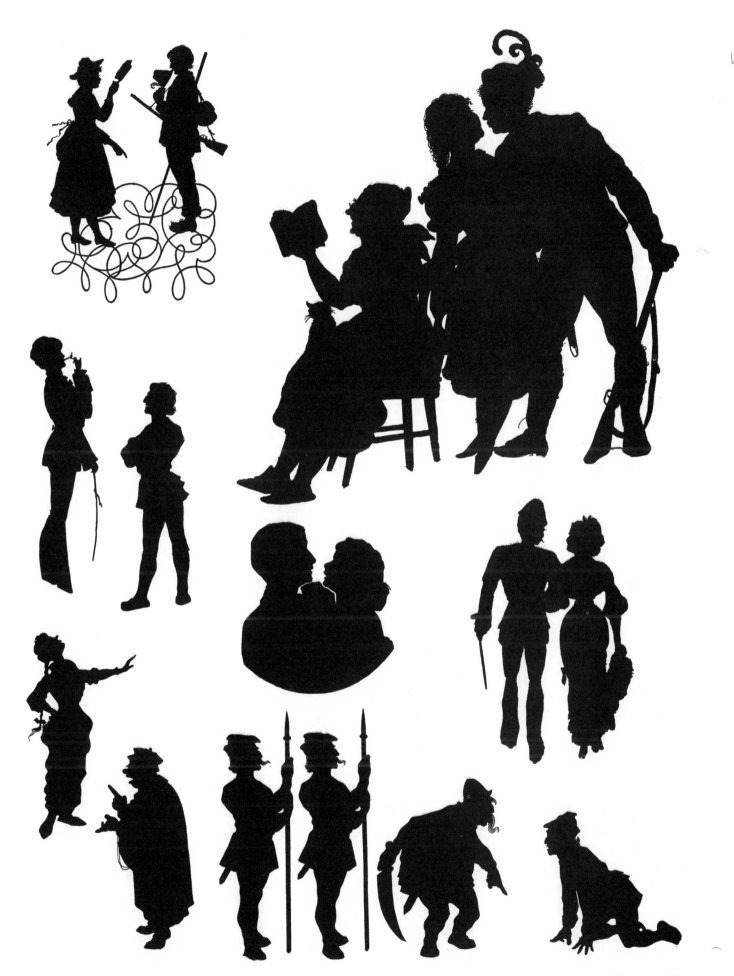

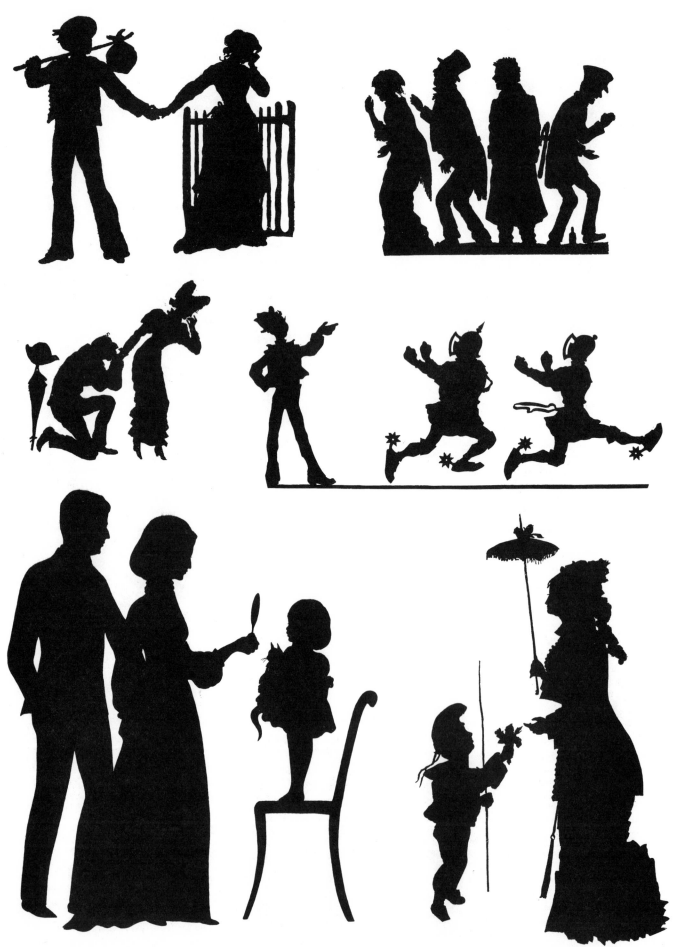

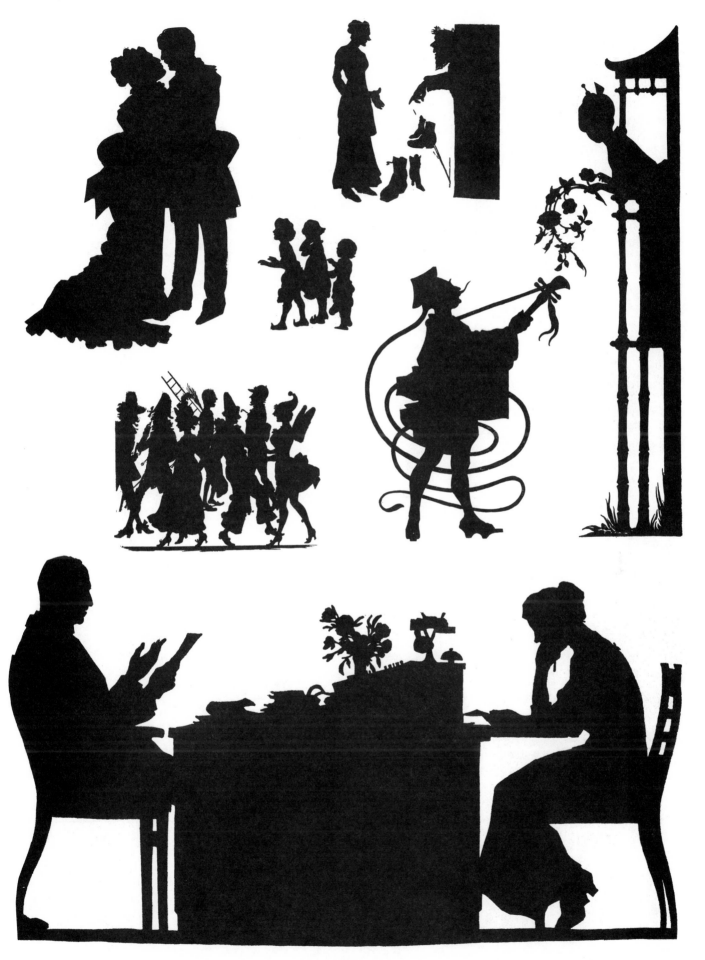

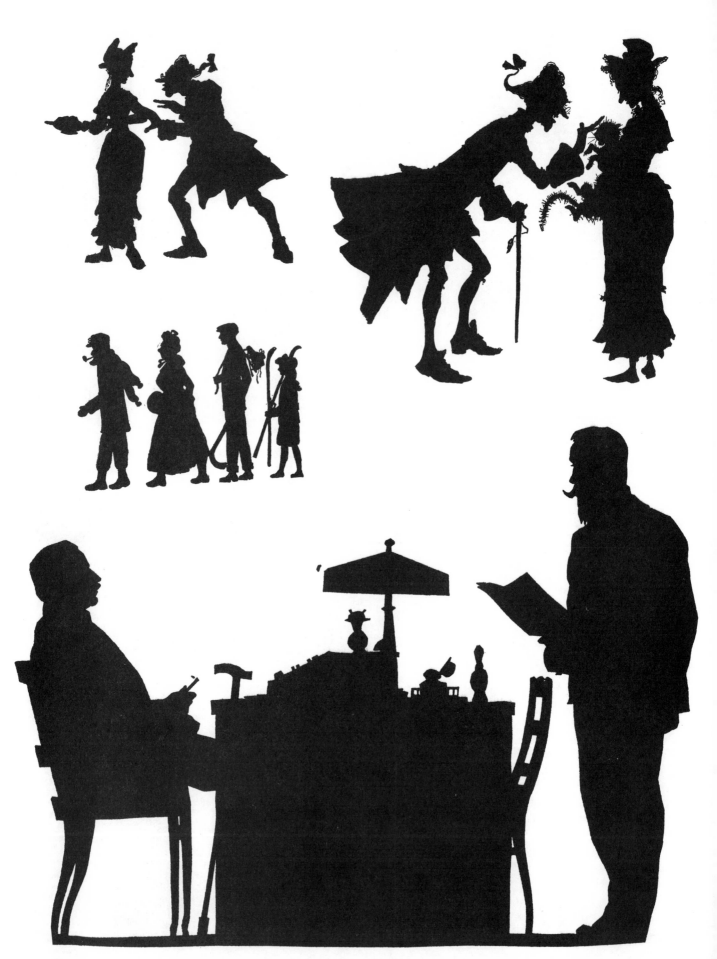

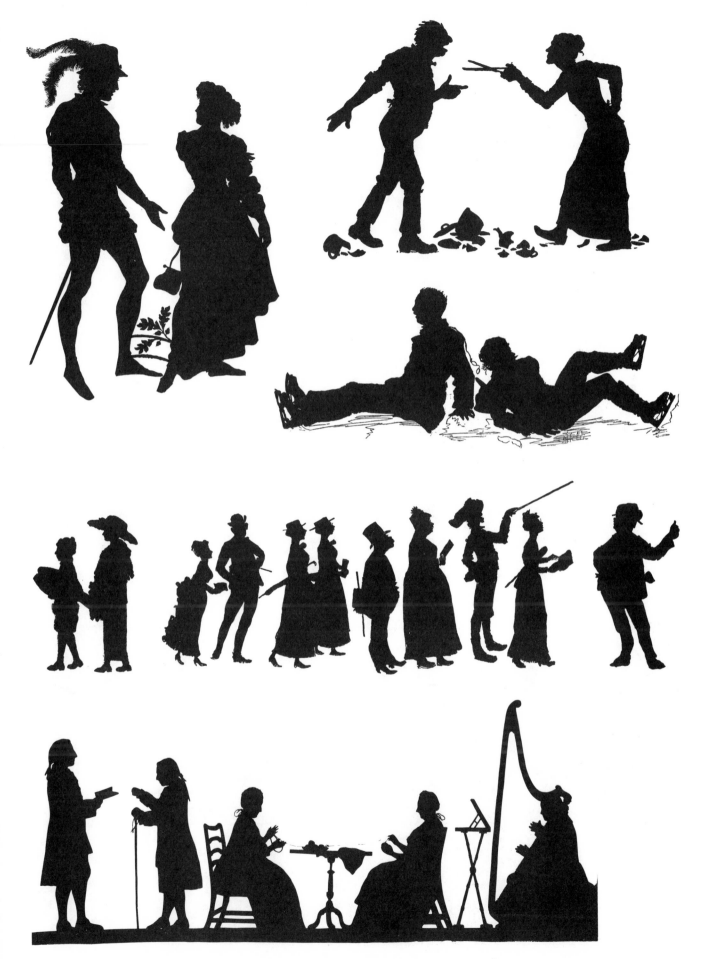

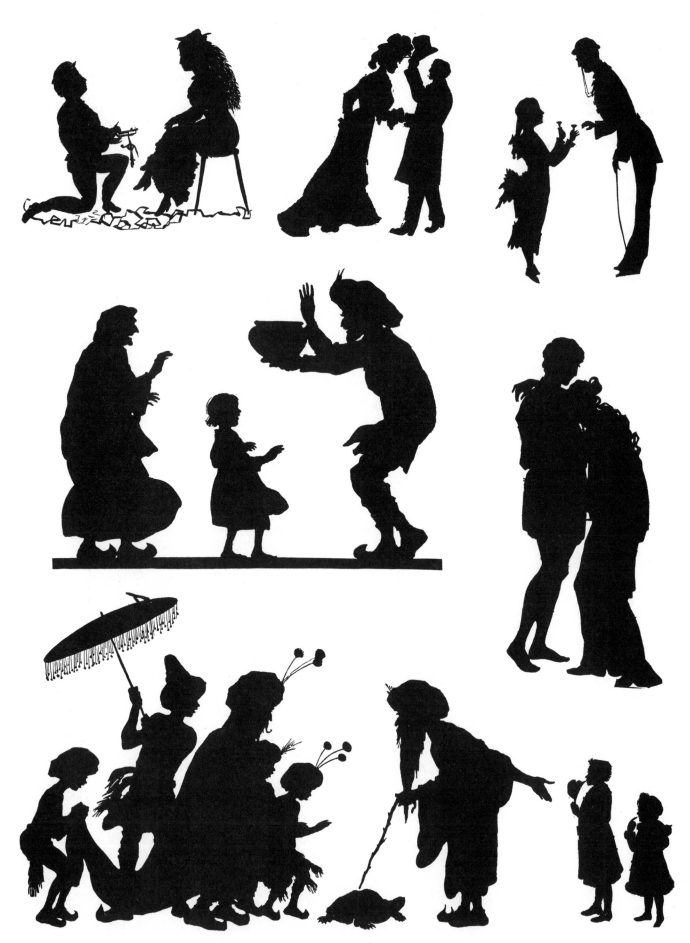

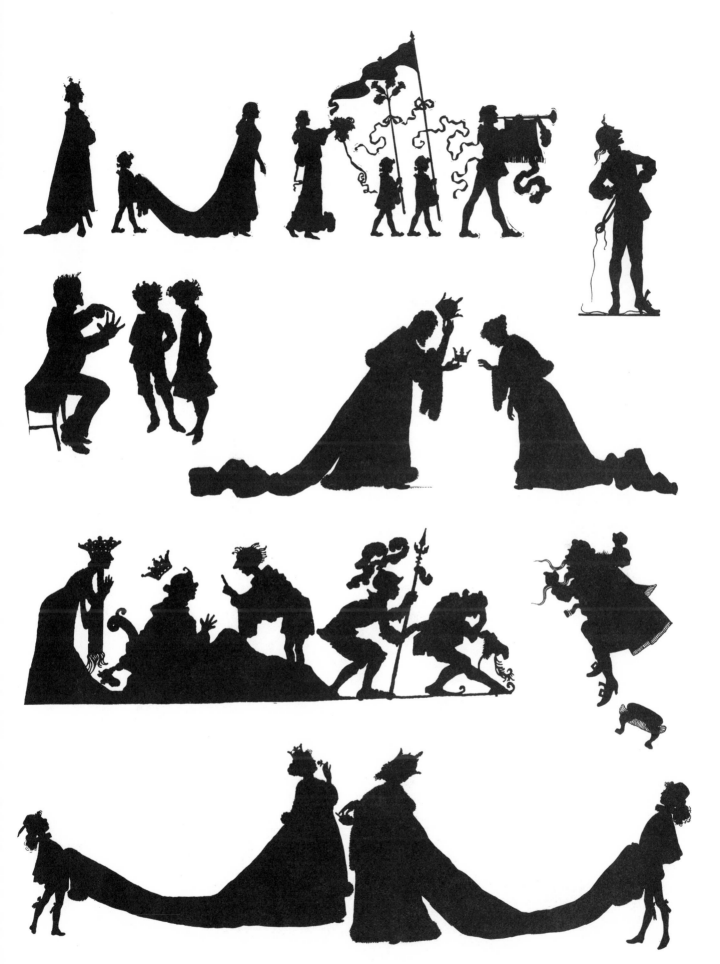

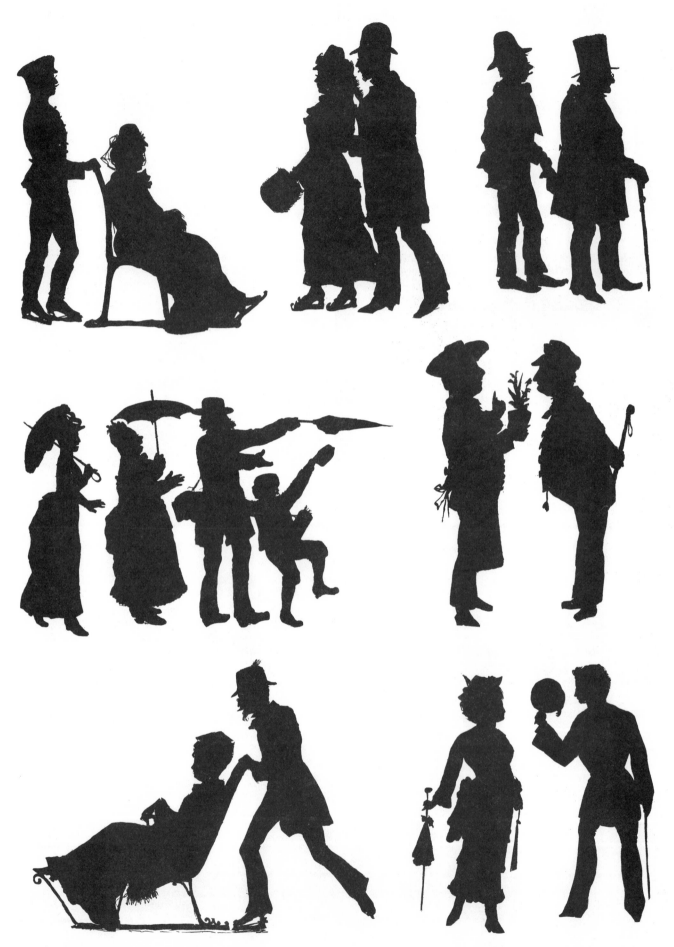

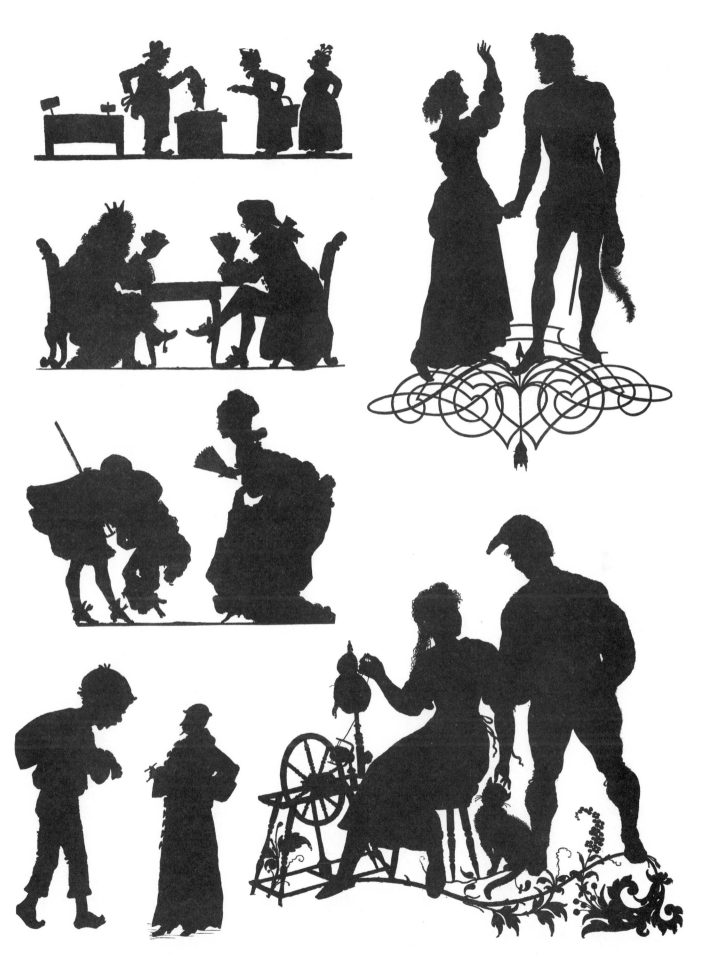

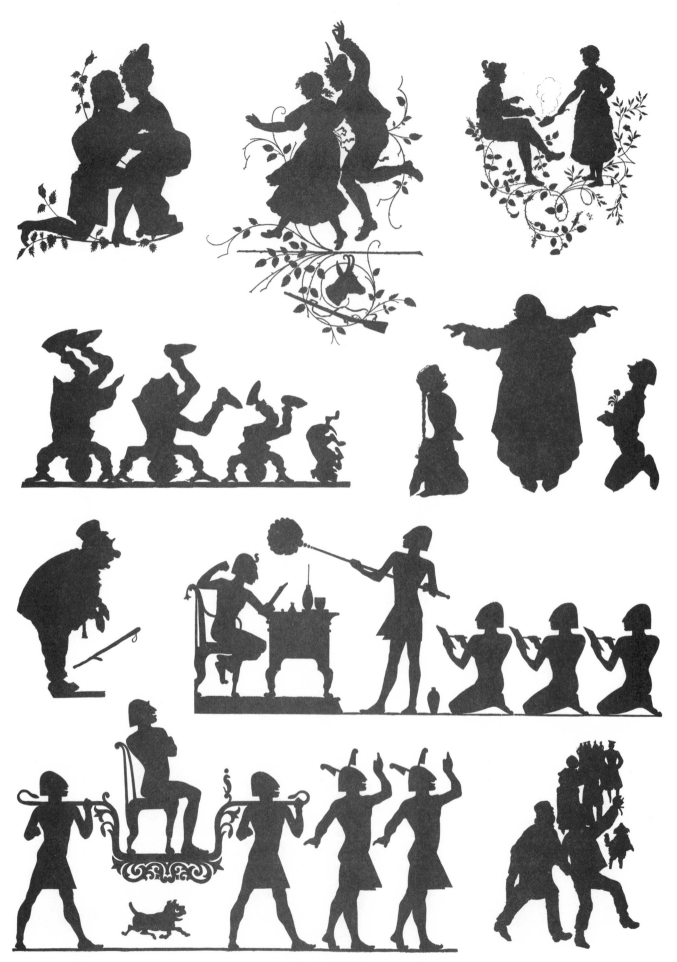

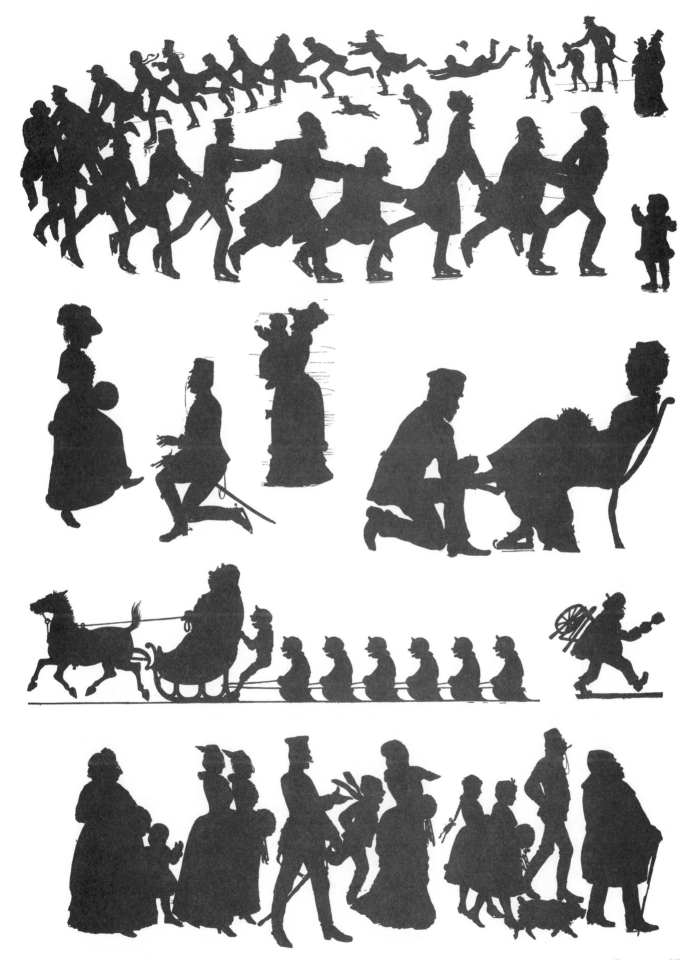

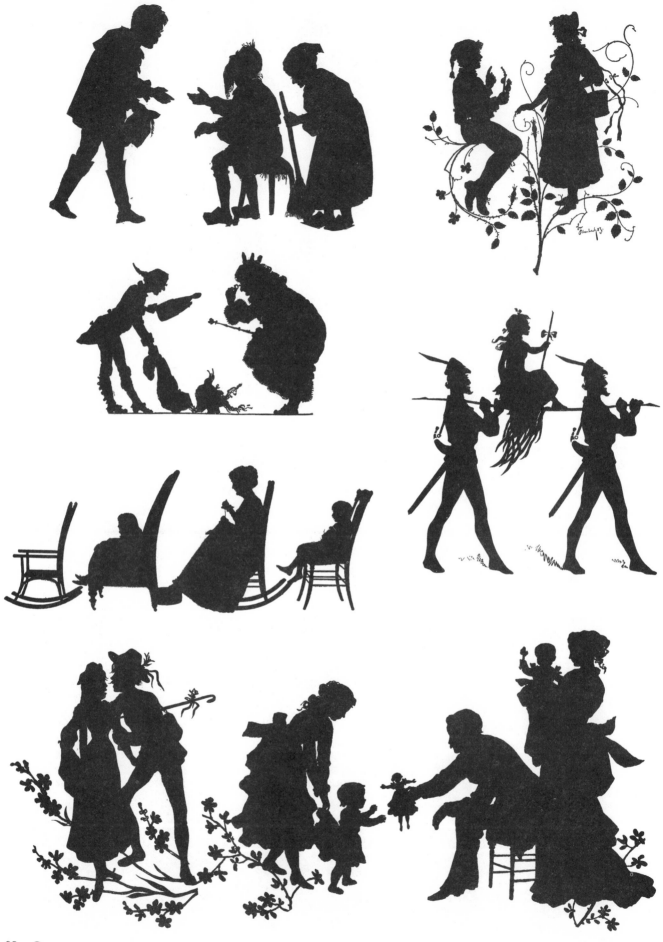

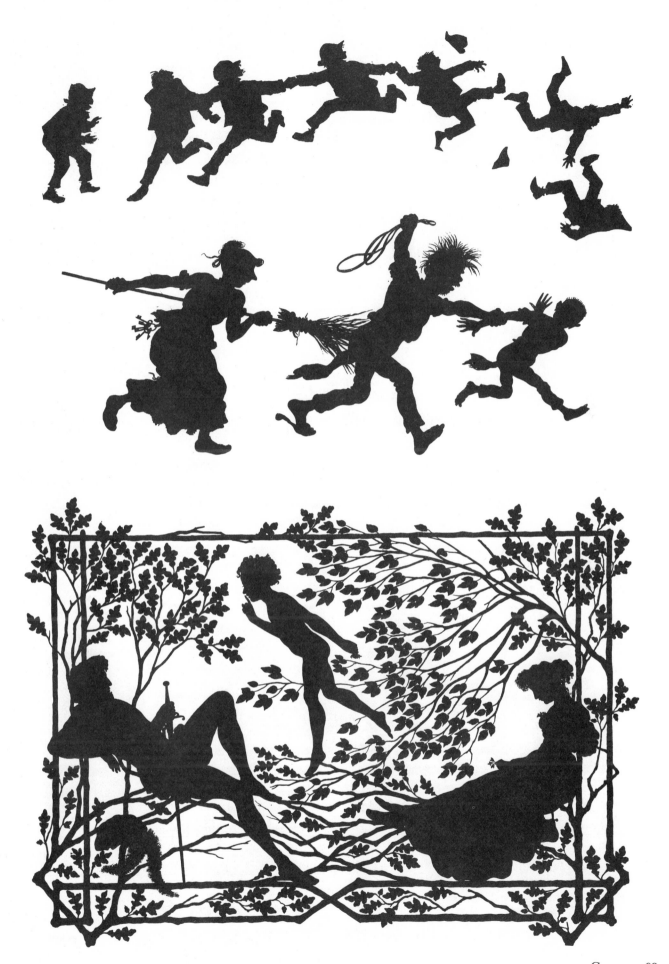

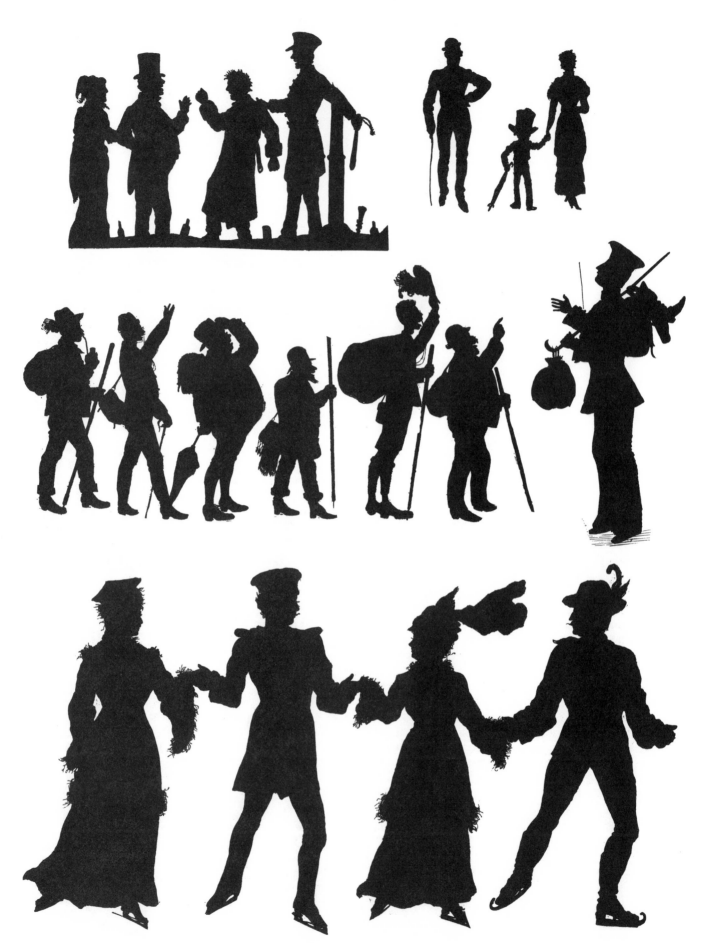

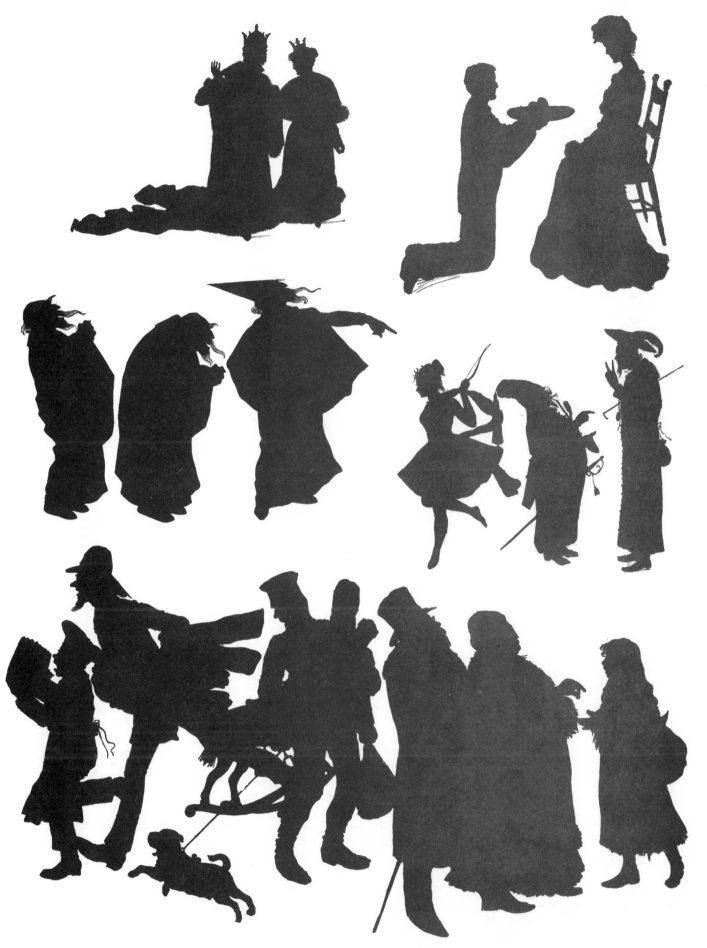

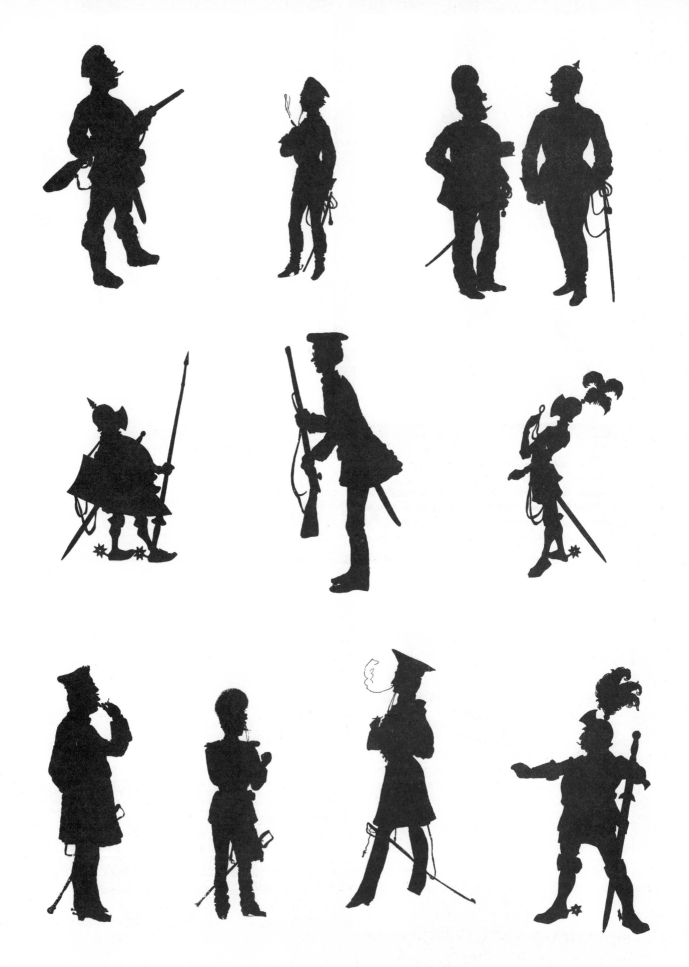

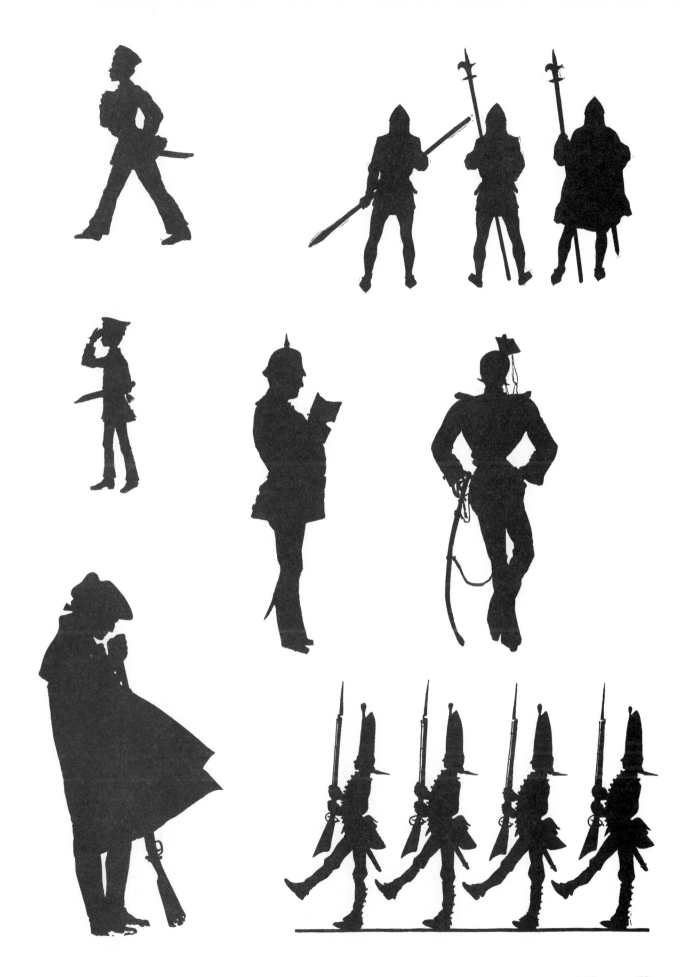

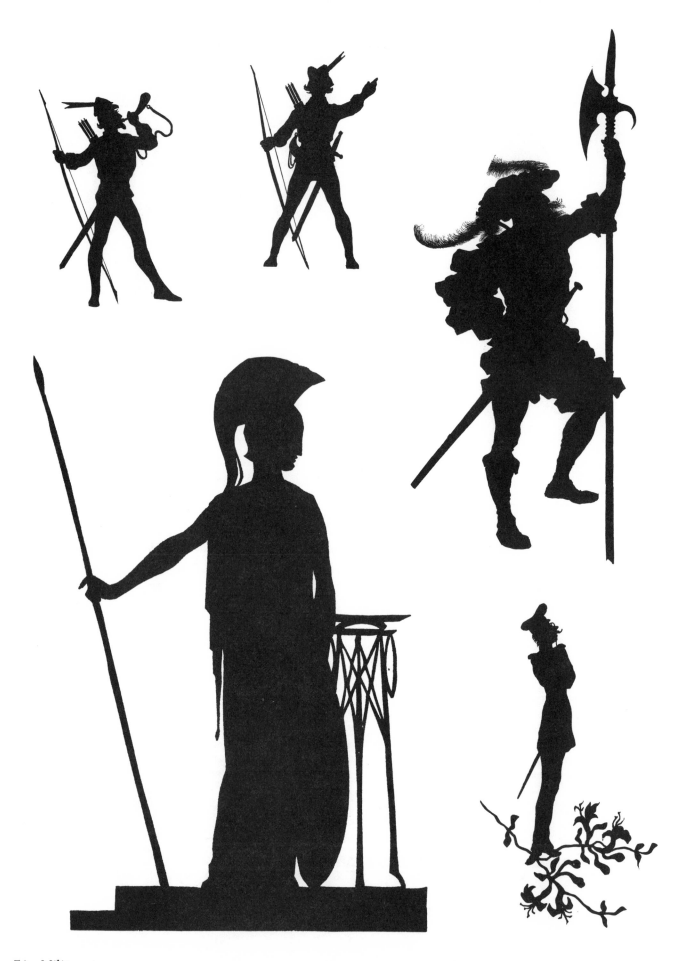

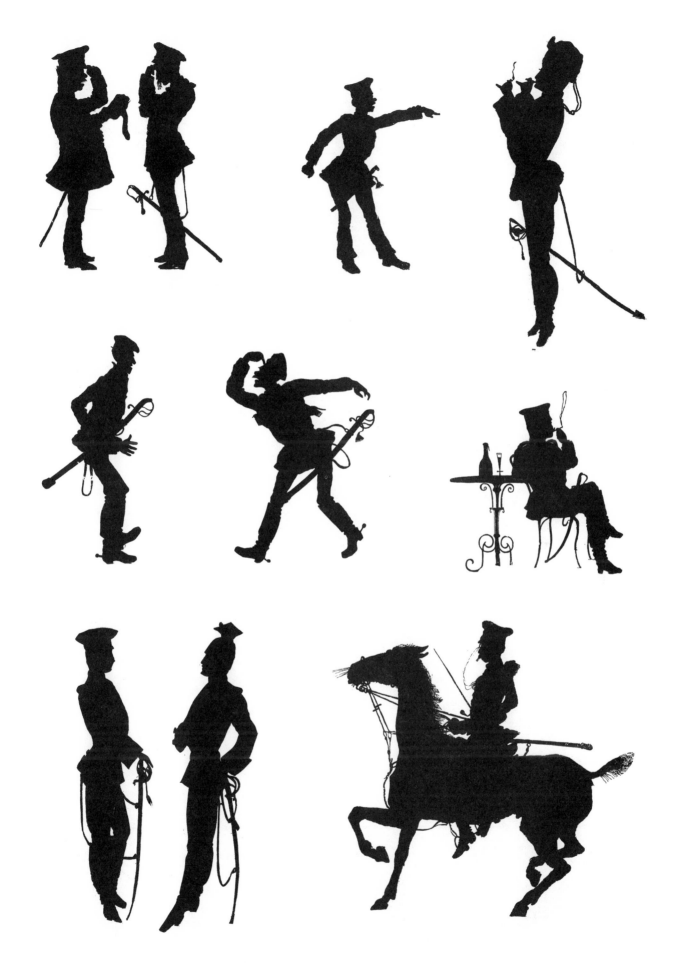

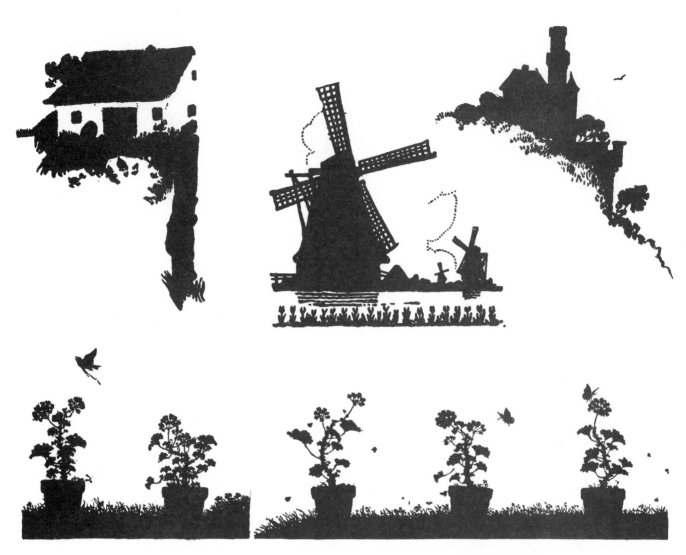

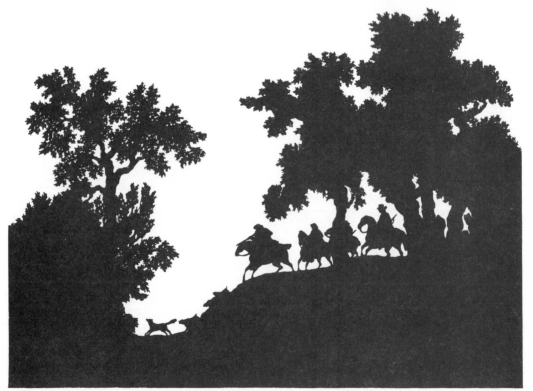

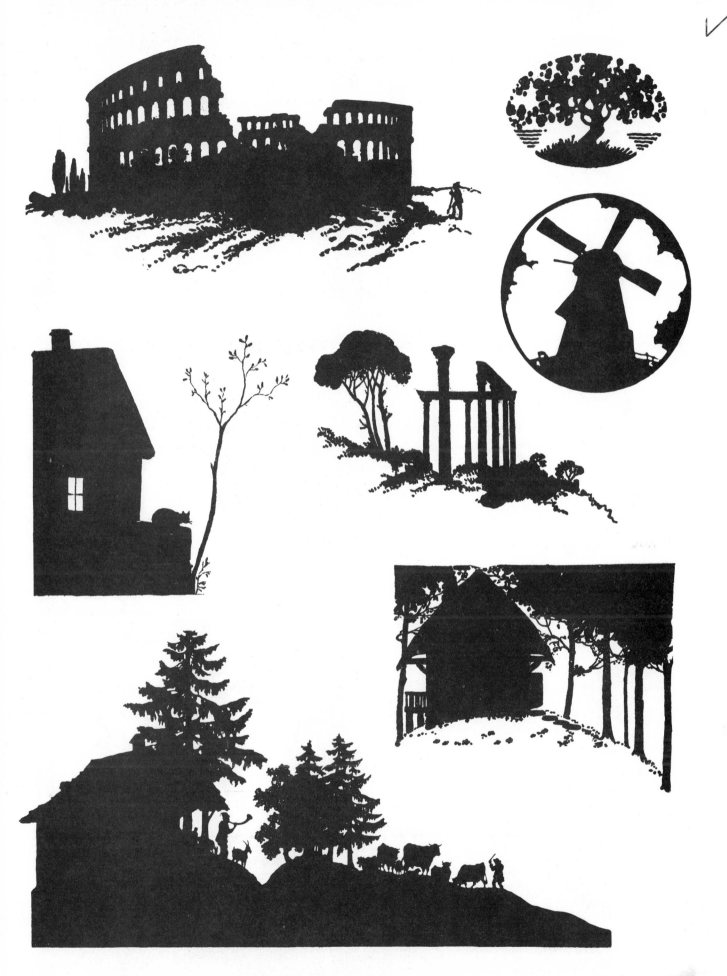

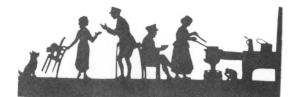

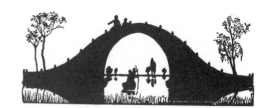

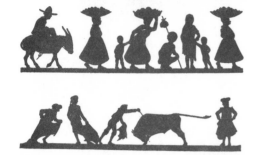

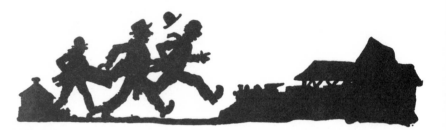

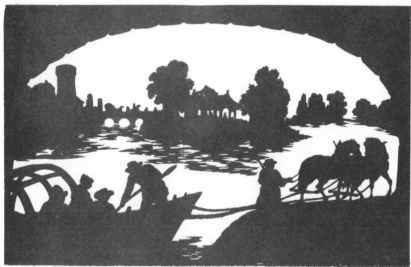

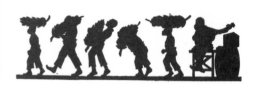

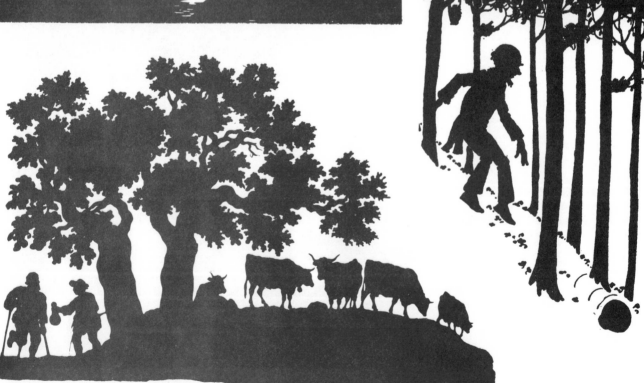

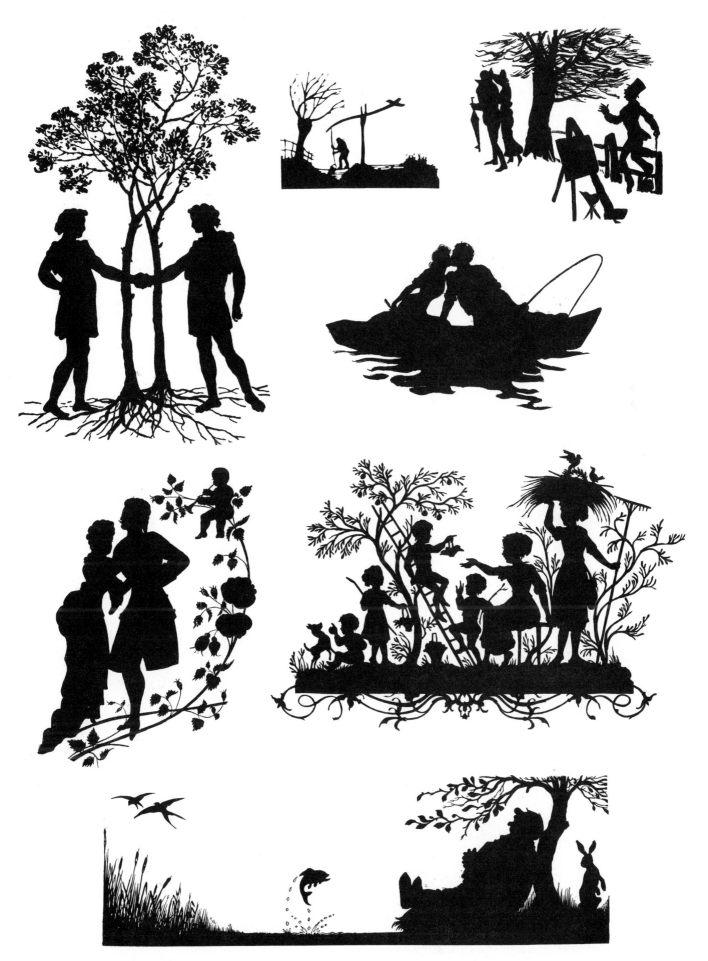

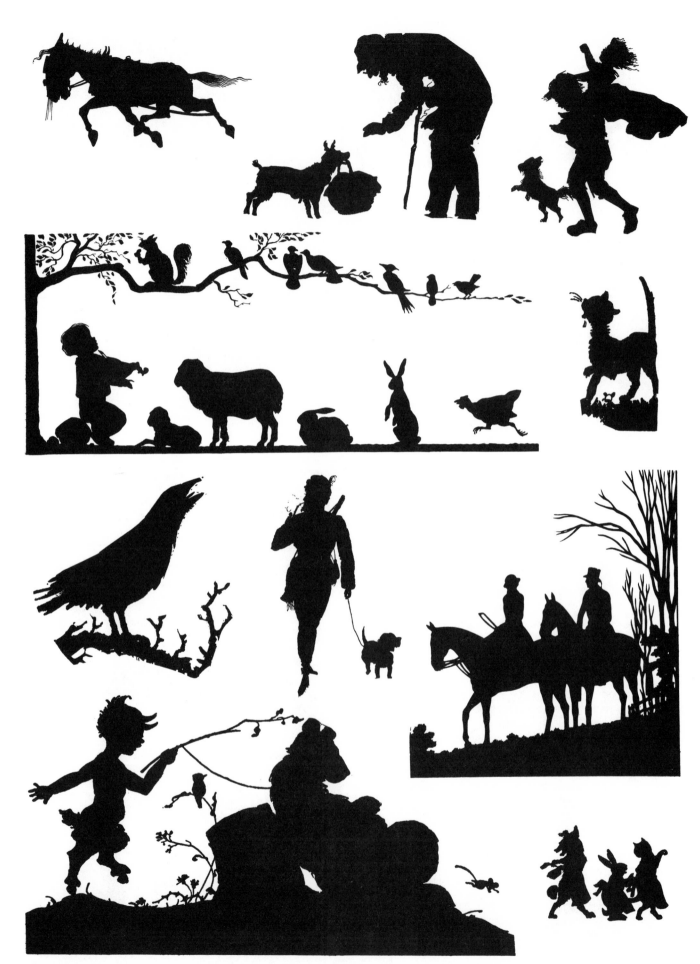

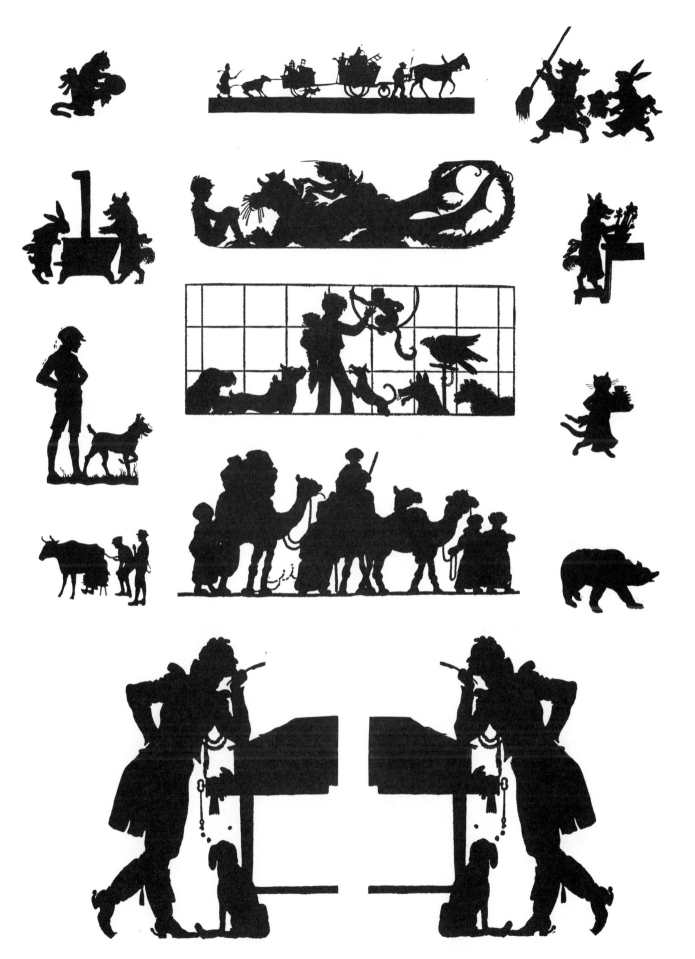

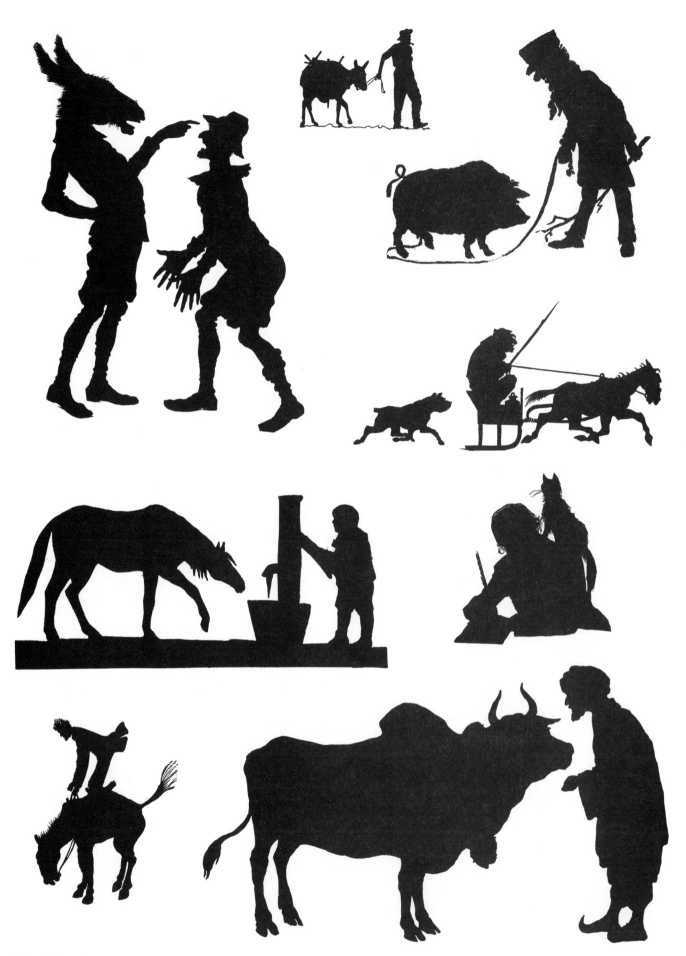

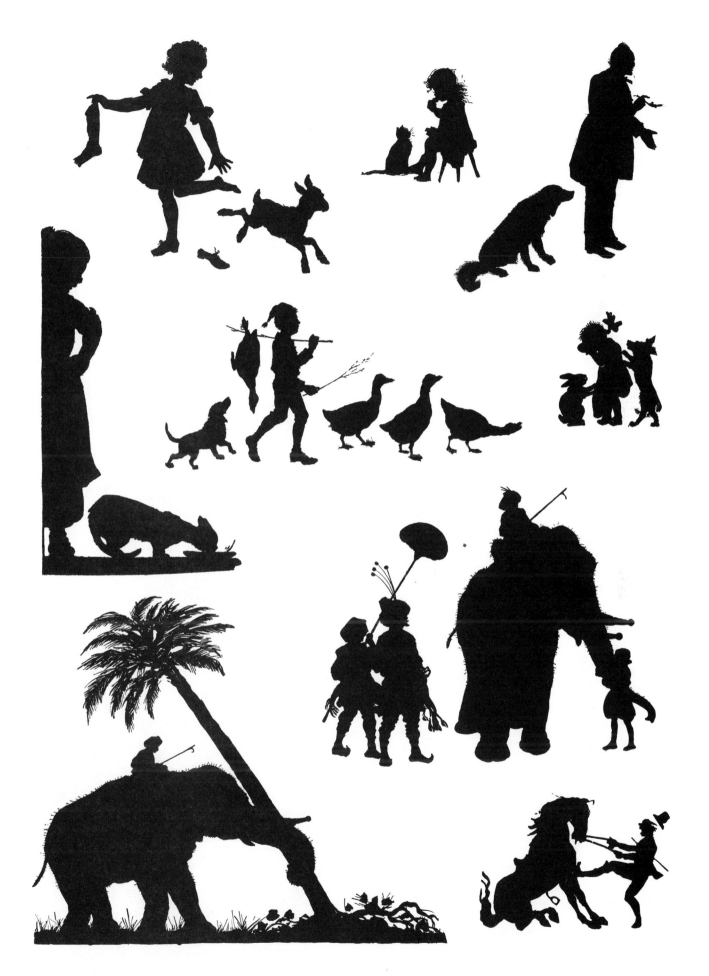

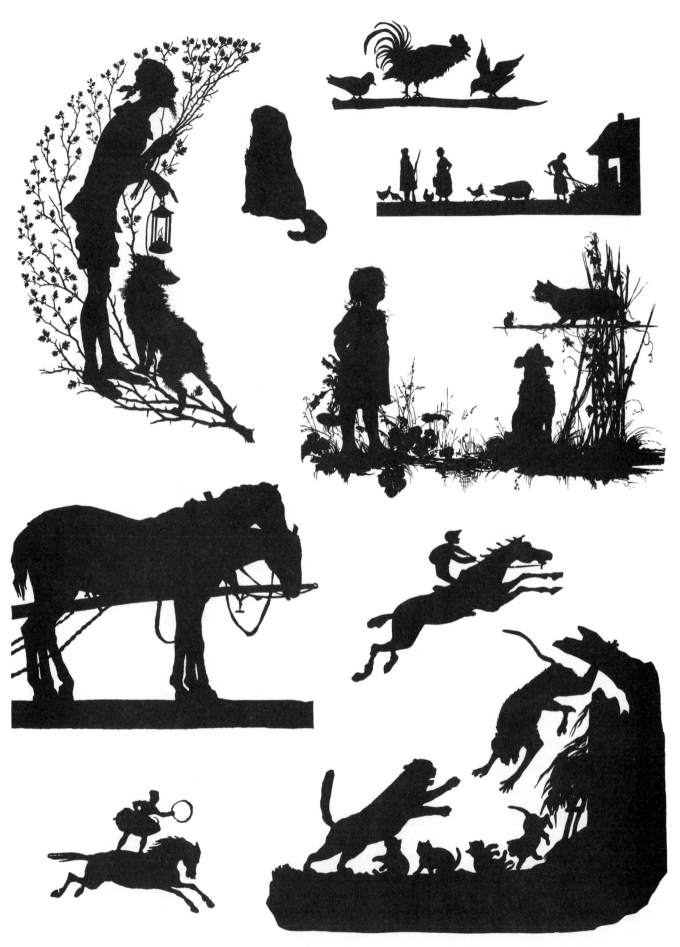

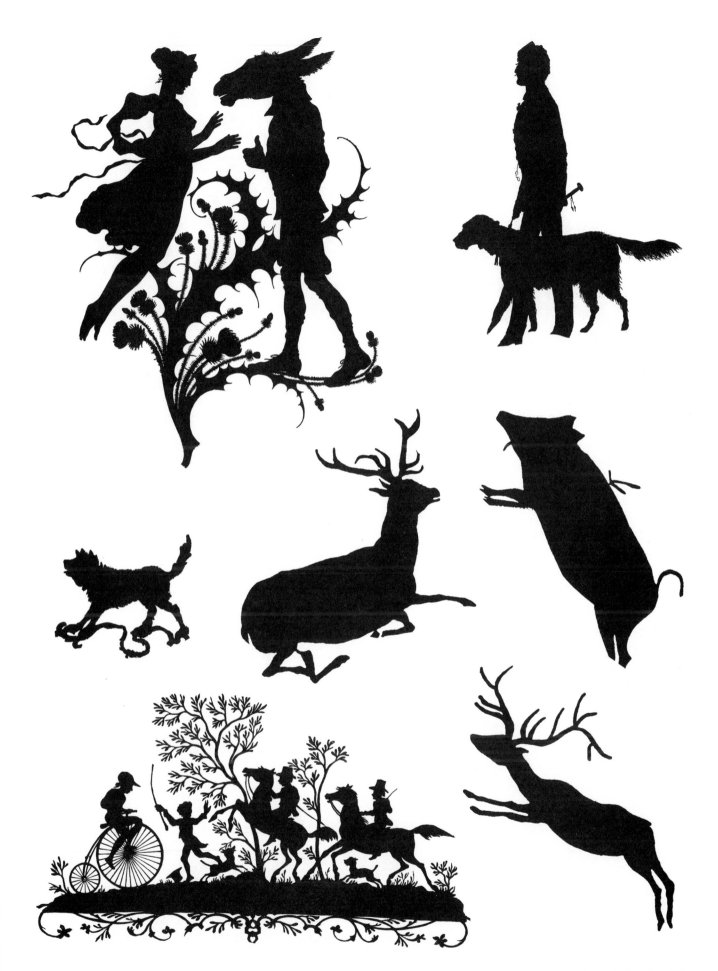

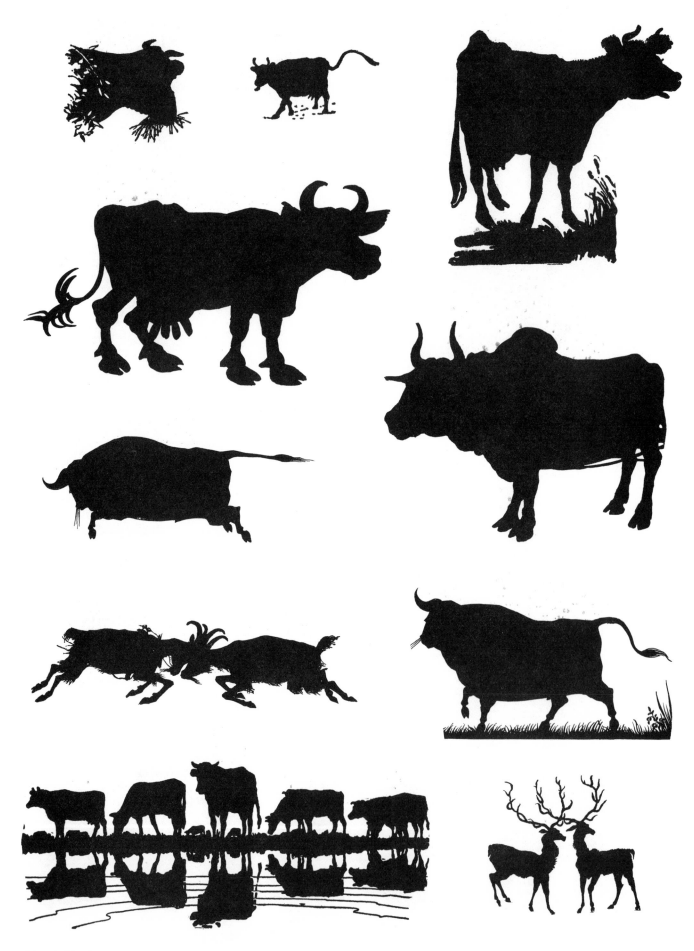

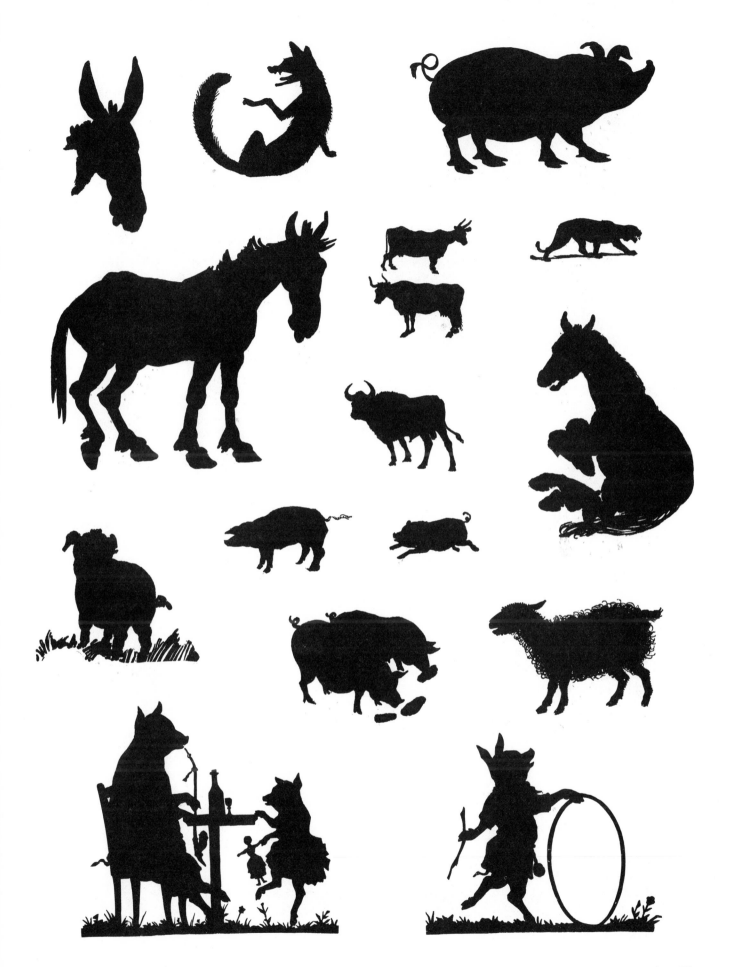

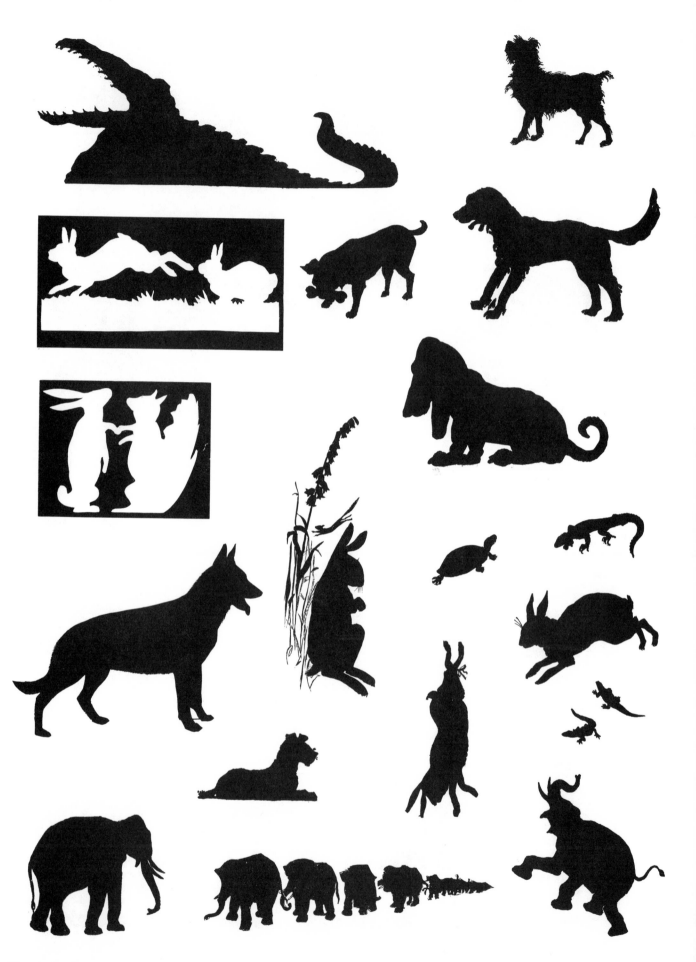

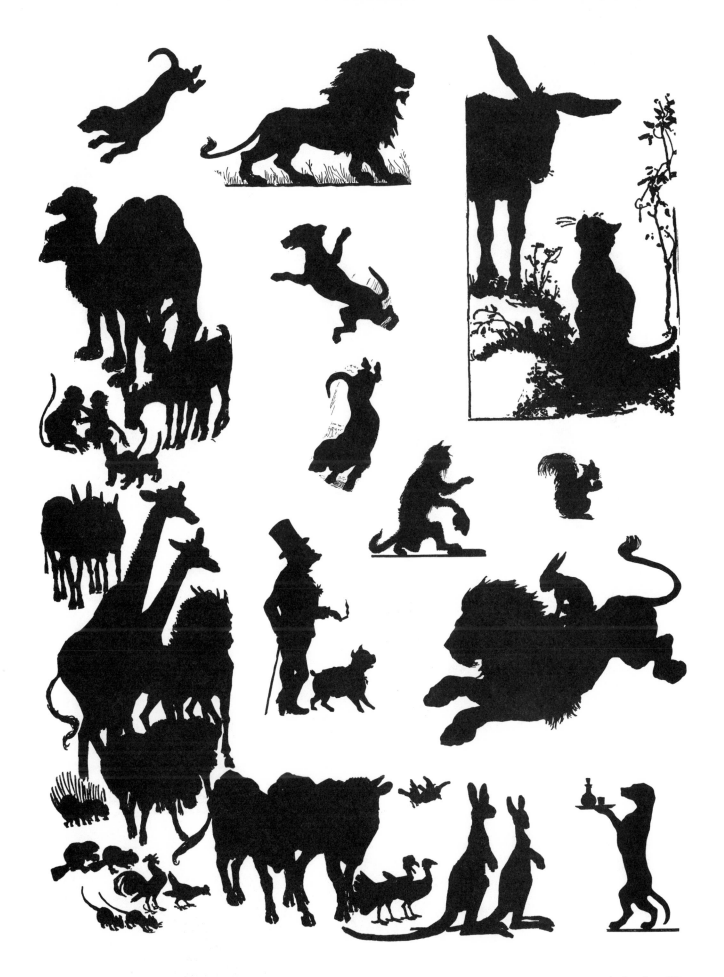

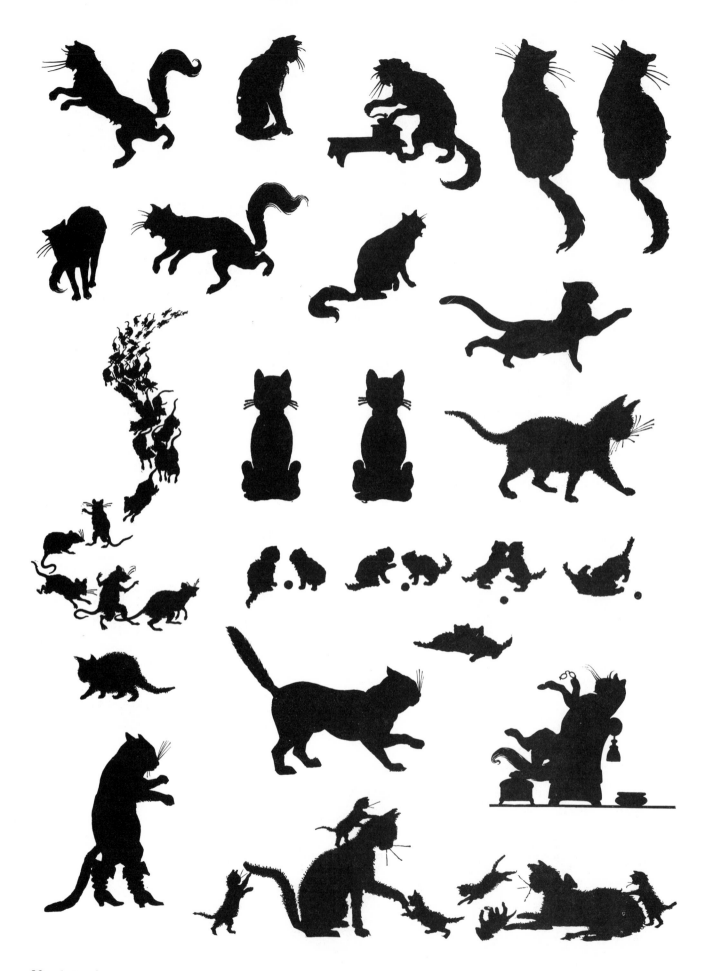

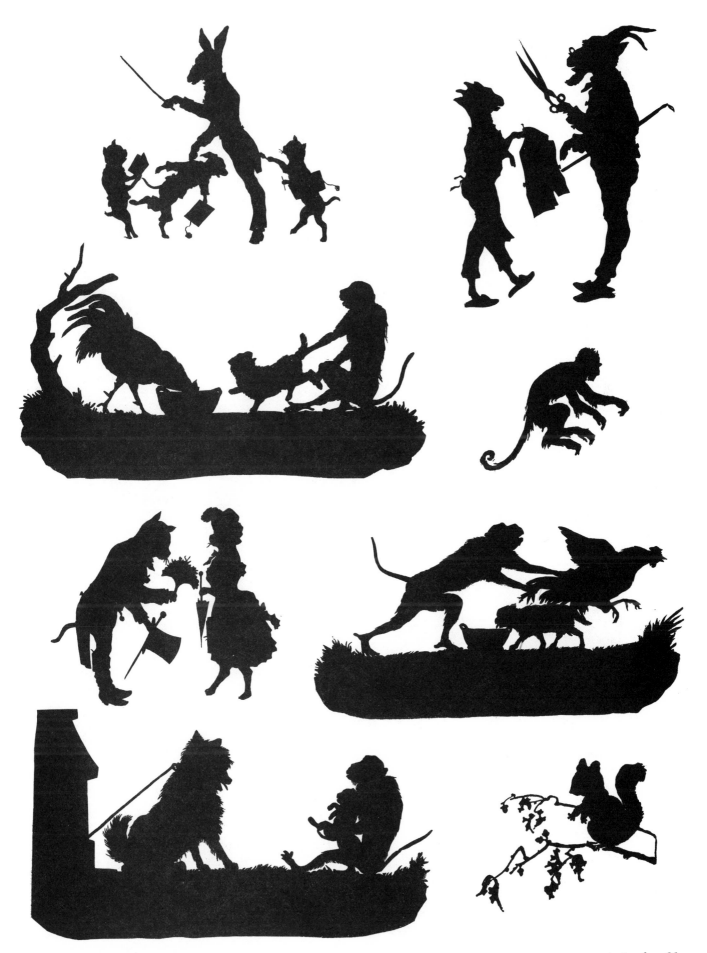

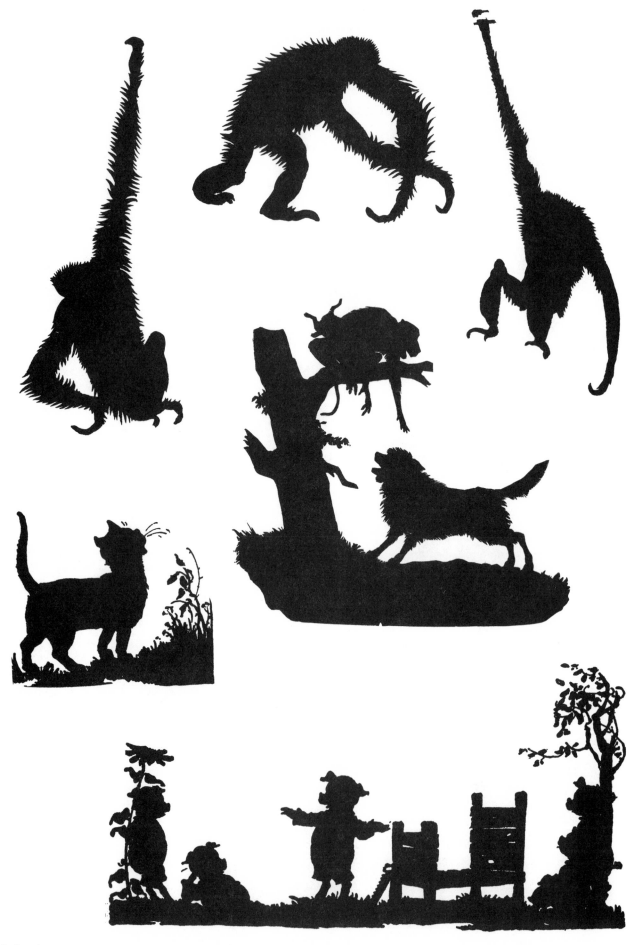

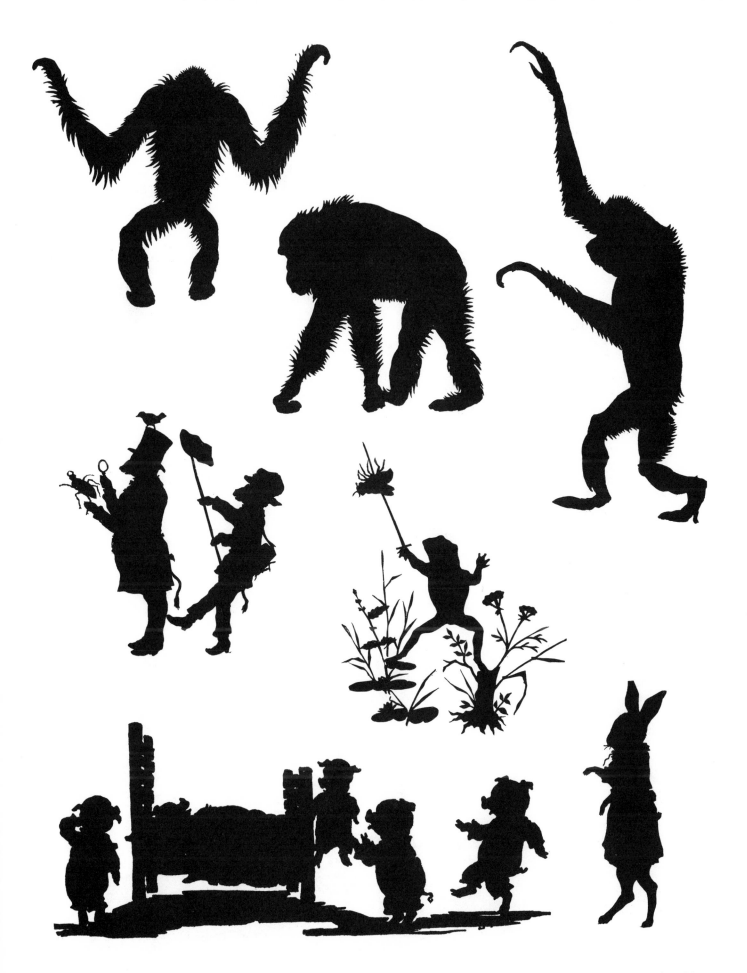

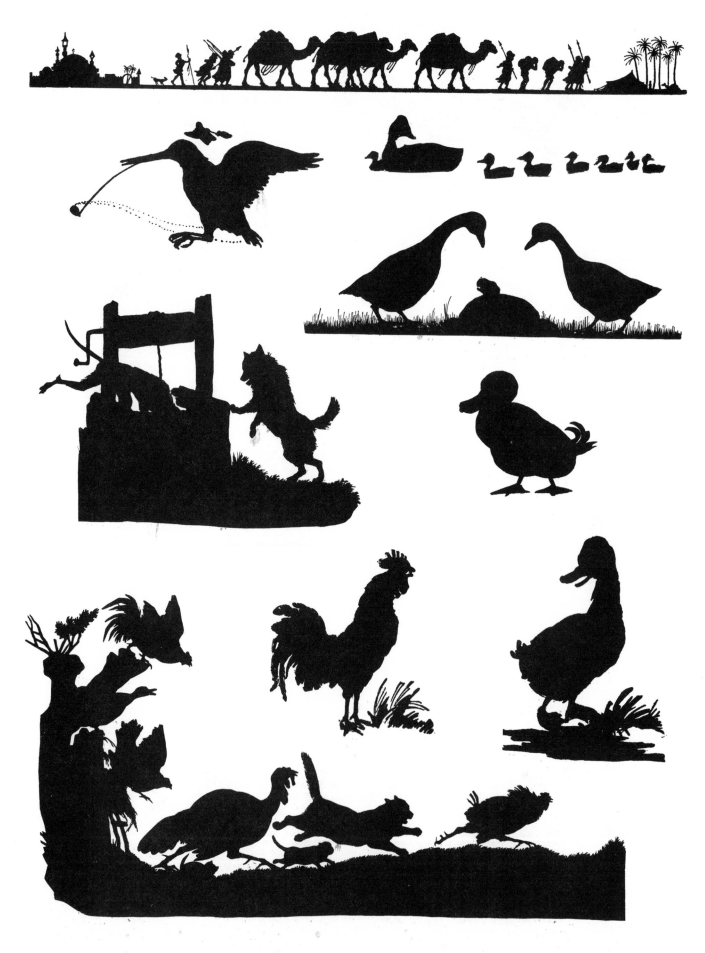

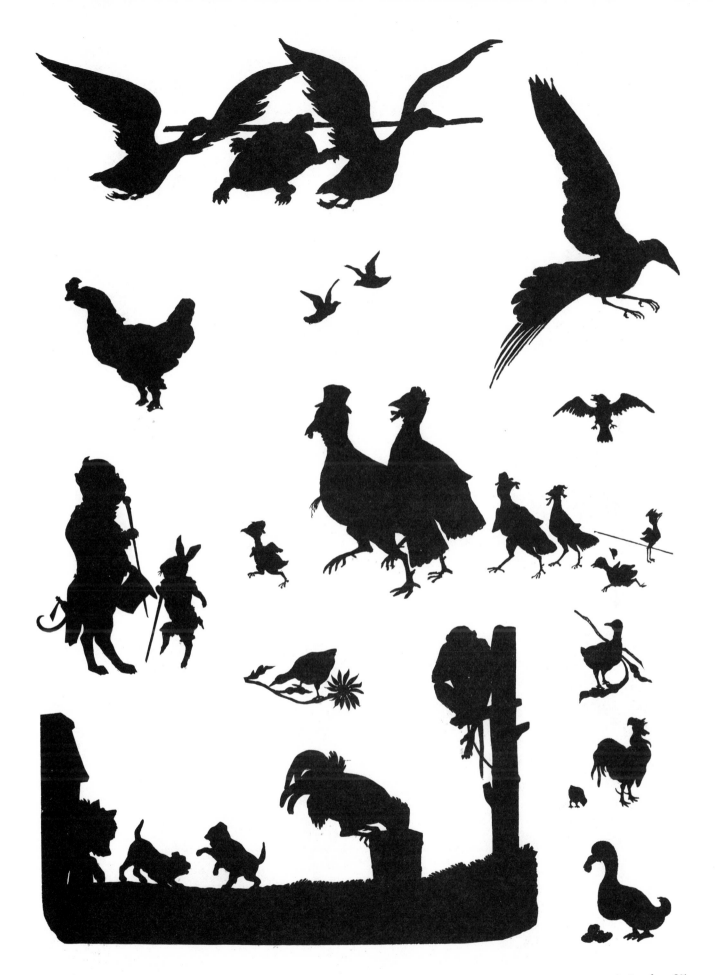

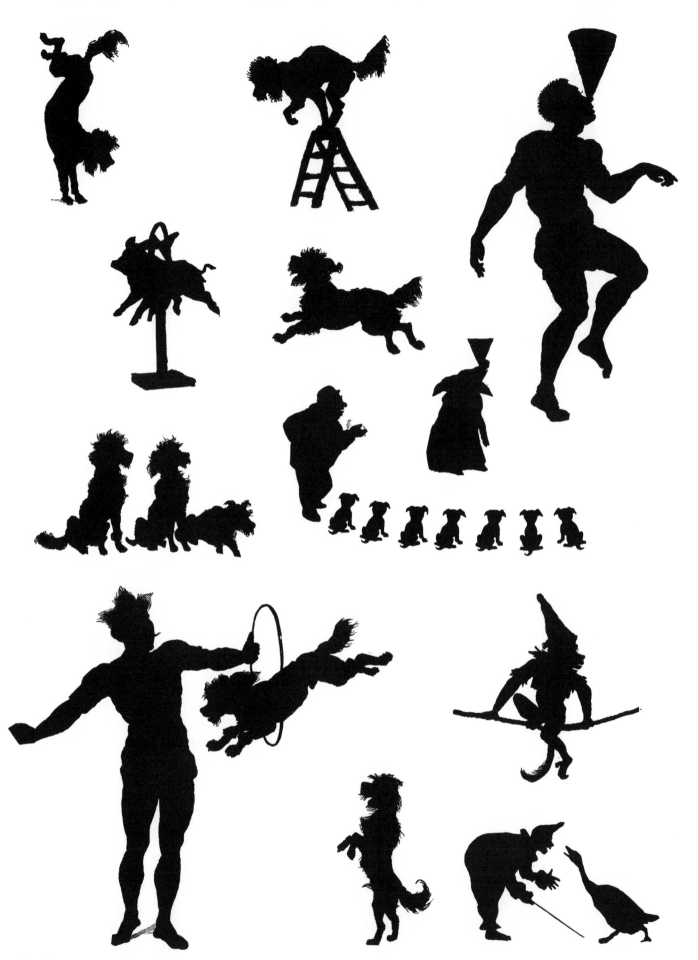

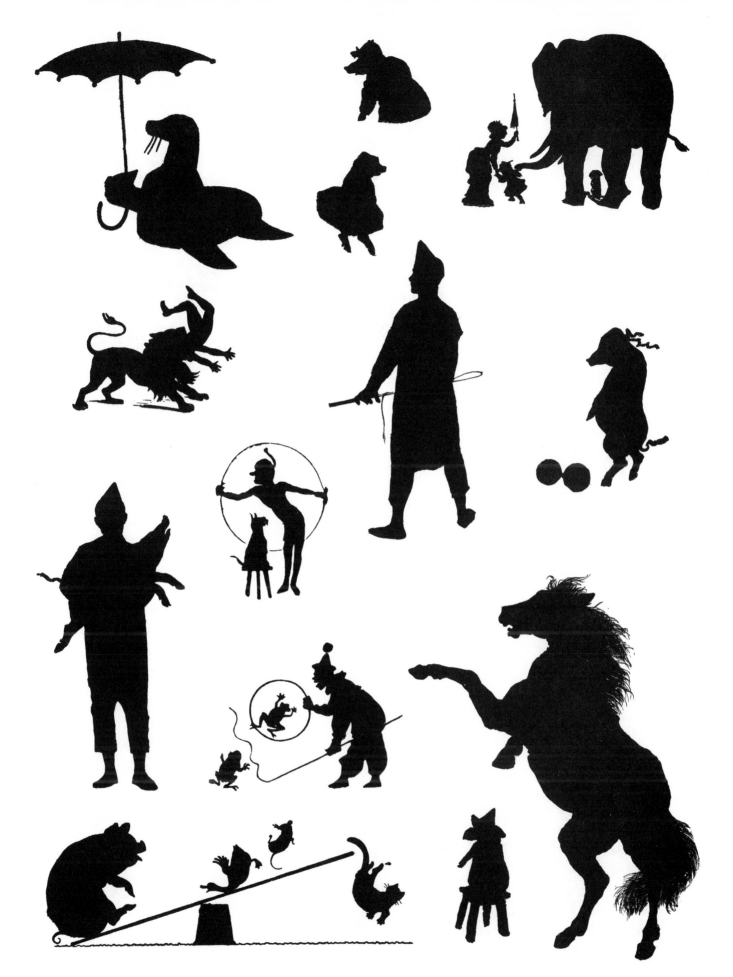

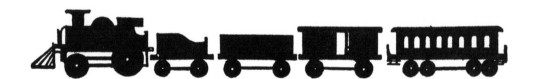
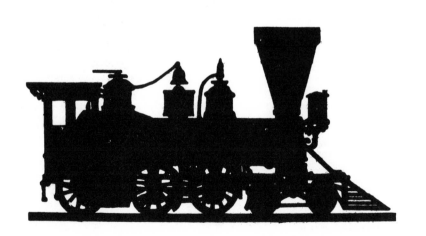
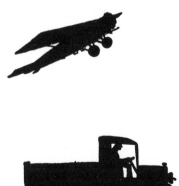

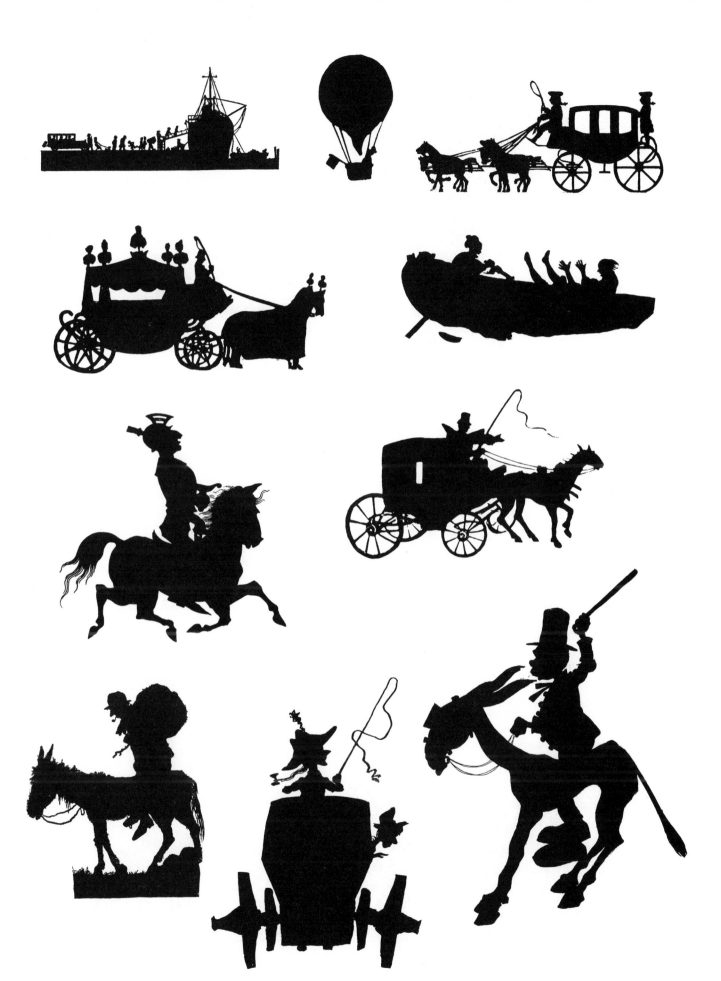

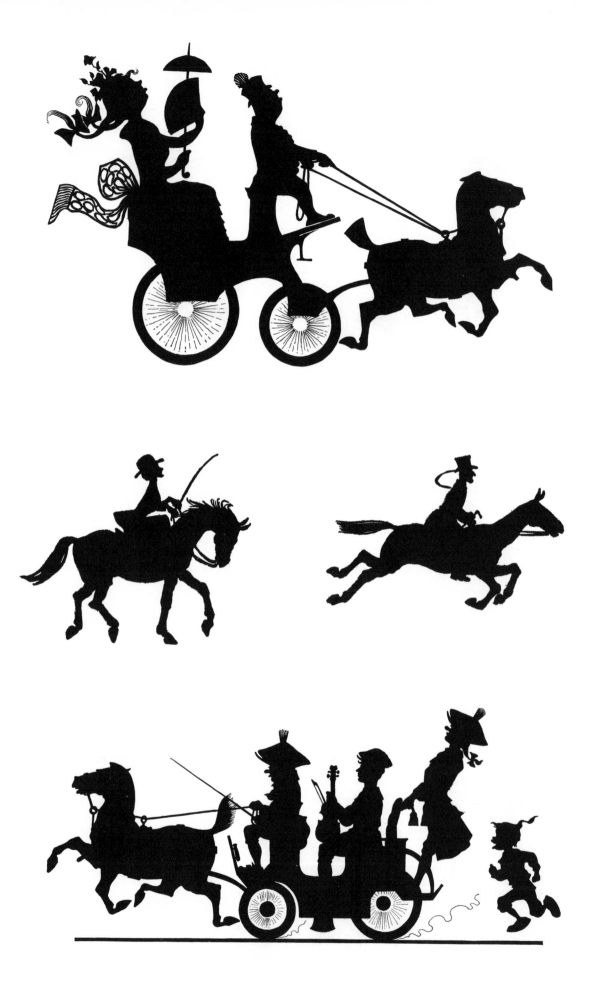

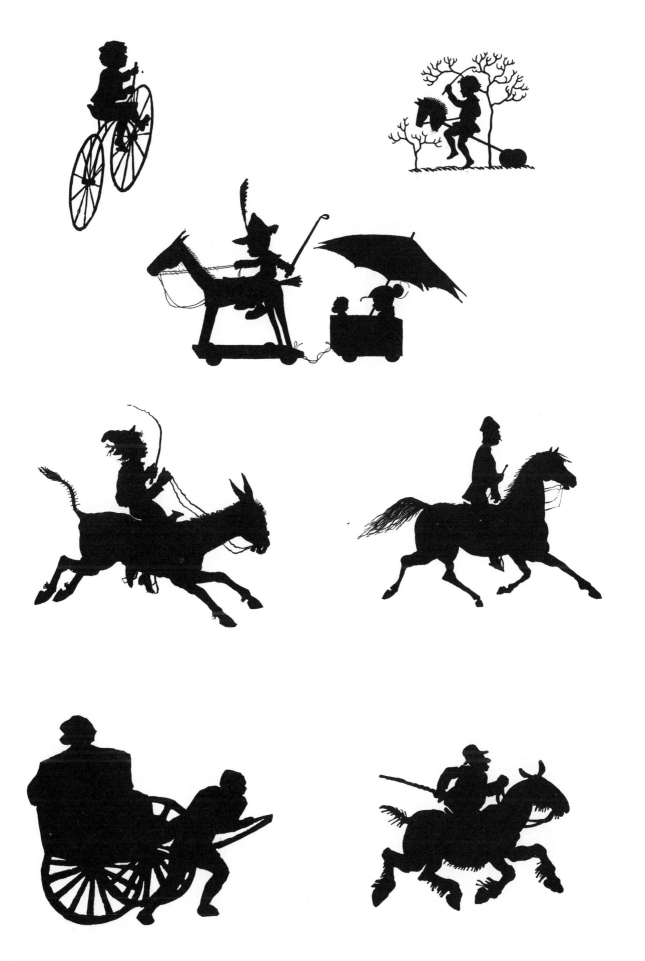

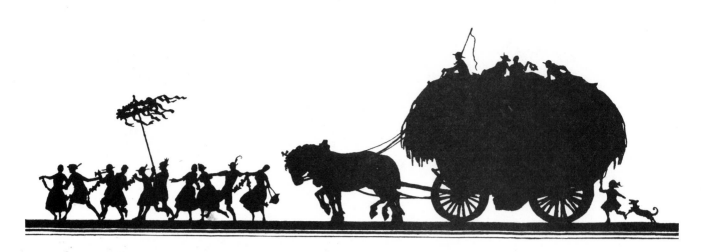

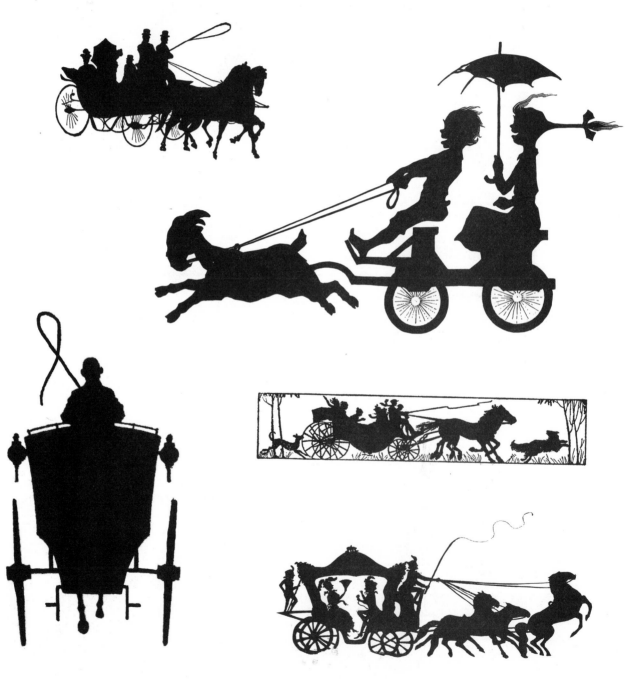

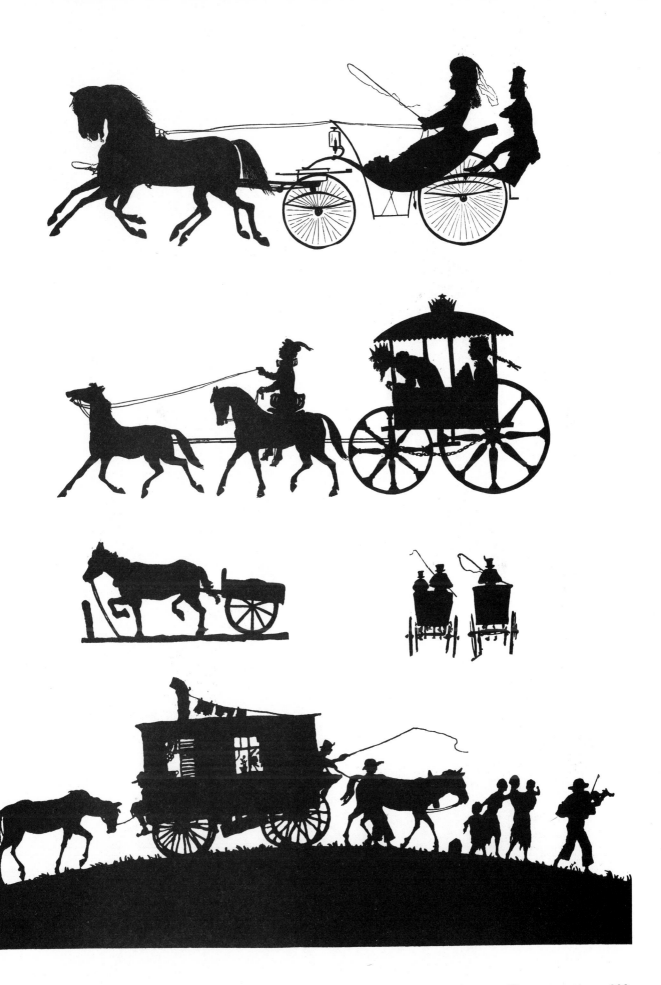

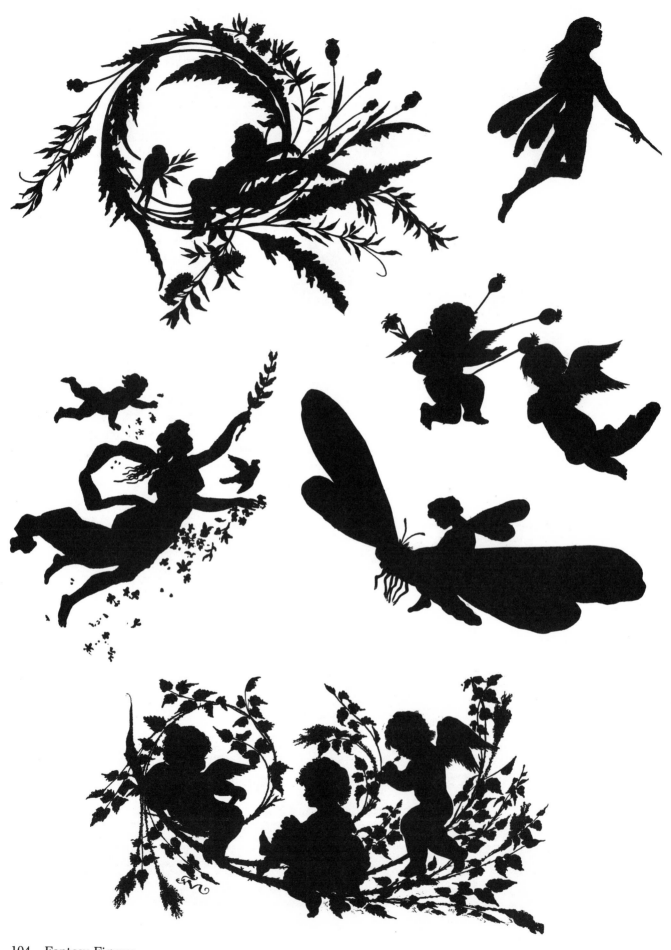

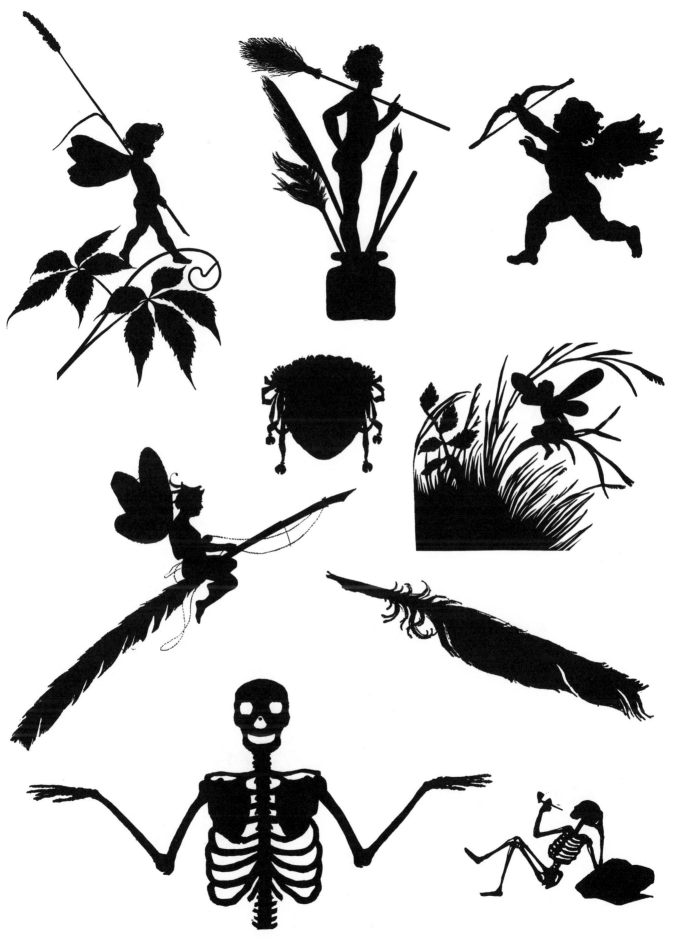

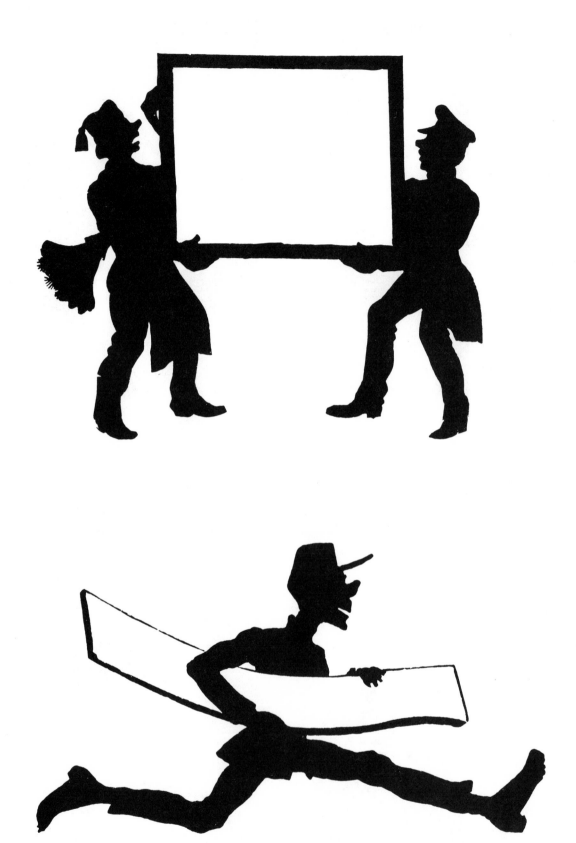